MASTERING THE ART OF
FABRIC PRINTING AND DESIGN

First published in the United States in 2012 by
Chronicle Books LLC.

Library of Congress Cataloging-in-Publication
Data available.

ISBN: 978-1-4521-0115-6

Cover design: Emily Portnoi
Cover photo: Ryann Ford
Photo styling: Robin Finlay
Art director: Emily Portnoi
Design and layout: Emily Portnoi

Manufactured in China.

10 9 8 7 6 5 4 3 2 1

Chronicle Books LLC
680 Second Street
San Francisco, California 94107
www.chroniclebooks.com

MASTERING THE ART OF
FABRIC PRINTING AND DESIGN

Techniques, Tutorials, and Inspiration

LAURIE WISBRUN

CHRONICLE BOOKS
SAN FRANCISCO

CONTENTS

INTRODUCTION

I've always been fascinated with the colors, the patterns, and the textures in a fabric store. Just walking into one makes my heart beat a little faster. For me, there's almost nothing as pretty as a pile of richly colored and patterned fabric beckoning to me with the possibilities of what I might create. I have an enormous stash of designer and vintage fabric, and adding to my collection is a never-ending process. And I'm certainly not alone in my passion for fabric.

The revival of handcrafted goods and society's celebration of artisanal design has helped to drive a renewed interest in textiles. As a byproduct of this interest, there's been an increased desire from individuals to design and print fabric for themselves. And for the first time, the tools to design, create, and market fabric without huge capital investments are readily available to DIYers and independent designers worldwide. This "democratization of design" has shifted the textile landscape and opened fabric design up to a new breed of designer.

Both the new generation of sewing enthusiasts and those who have been sewing for decades are seeking fresh and innovative fabric. The fabric manufacturers are listening and are actively recruiting new designers to provide an infusion of new styles into their lines. Until now, it's been a challenge for independent designers to demonstrate how their designs would translate to fabric, and to get their work noticed by the manufacturers and the marketplace at large.

Access to tools for designing and printing fabric digitally, combined with online marketplaces and the Internet, have all converged to provide the aspiring designer with all the tools and inspiration needed to create fabric digitally and promote it globally. Tried-and-true methods such as screenprinting or hand-dyeing have seen dramatic changes as this new breed of artist experiments and creates new approaches to an old art form.

Although this book is primarily geared toward designing and printing fabric digitally, the techniques included are applicable across a broad range of creative outlets. This is the book I wish I'd had when I started designing fabric. As an untrained artist and designer, I longed for a single resource to guide me through my exploration of the dynamic and exciting field of fabric design and production. I hope this book will become that resource for you and that it inspires you, guides you, and encourages you to follow your dreams of designing and printing fabric.

Laurie

Laurie Wisbrun

Tufted Tweets by Laurie Wisbrun for Robert Kaufman Fabrics

CHAPTER 1
UNDERSTANDING PATTERNS

As you begin your journey into designing and printing fabric, this chapter will prepare you with a quick primer covering the different motif categories of fabric designs. Next you'll find some basics surrounding color theory and general aspects of layout. I hope this information is helpful to you as you begin to think about your next design.

Floral motifs with differing scale and density

GEOMETRIC MOTIFS

The word *geometric* probably brings to mind the typical shapes from your childhood lessons. Squares, circles, triangles, diamonds, and hexagons certainly qualify as geometrics. But in fabric design, any abstract or nonrepresentational motif (meaning something that is not recognizable as an object) is considered a geometric. Geometrics are not limited to straight and hard lines, though. They can feature softer approaches such as wavy bands of color, paisleys, and concentric circles. Even splatters, squiggles, swooshes, and blobs are considered to be geometrics.

When paired with other prints like florals or novelty designs, a geometric can act as an anchor and give the eye a place to rest. Although traditionally used to line bags, bind quilts, and to provide simple accents on apparel, geometrics are certainly strong enough to stand on their own.

5

Experimenting with geometrics will help you to develop a sense of how to combine shapes together in order to create patterns. Start with a small icon that can then be repeated and manipulated by changing the direction or the scale of the icon to create a pattern. Keep trying different modifications and you'll start to see different patterns emerging just by making some simple changes between versions. Another approach to designing a geometric is *tessellation*. A tessellation is created by continuously repeating a shape to completely cover the plane in interlocking patterns, leaving no blank areas or overlaps between the objects.

As you start designing with geometrics, follow your creative instinct and think about ways to combine your geometric objects in unusual ways.

4

1 Mari fabric designed by Hitomi Kimura

2 Yellow Mod & Dot Bangle wristlet by Kailo Chic, stationery by Smock

3 Curly Swirl fabric by Pillow & Maxfield for Michael Miller Fabrics

4 Wood Ear by Kaffe Fassett for Westminster Fabrics

5 Crazy About Blue fabric by Natalie Callwood

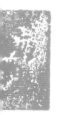

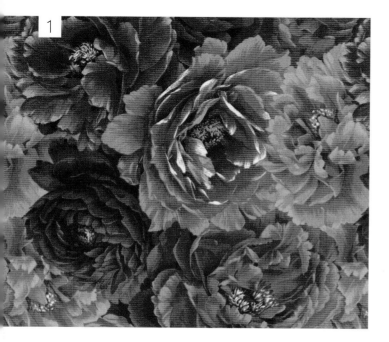

FLORAL MOTIFS

Mother Nature provides a rich palette from which to draw inspiration for floral motifs. Florals are a popular subject for fabric designers, and are one of the most widely created and sold categories of textiles. Don't let the abundance of floral designs deter you from trying your hand, though. With the beauty and diversity of unique shapes found in our natural environment, this category is burgeoning with opportunities to create a breadth of designs.

1 Charlotte, a romantic, densely packed floral design from Michael Miller Fabrics

2 A modern approach to floral fabric design, Palm Fan fabric by Kaffe Fassett for FreeSpirit Fabrics

3 Inspired by the native eucalyptus of Australia, this delicate floral by Jennifer Berney features a simple silhouette

4 Verdant and leafy Variegated Garden fabric from Martha Negley for Westminster Fabrics

5 Art nouveau florals are a naturalistic and stylized representation, often combined with semicircles or ovals. Nouveau Trees zipper pouch by Hippopotamus Gifts

6 Dill Blossom fabric from SEI for Robert Kaufman Fabrics demonstrates a stylized approach to floral designs

7 Feedsack prints have evolved from their humble roots as early grain packaging patterns and often feature small or micro florals. Gingham floral from Feedsack VI circa 1935 by Windham Fabrics

Floral patterns can be executed in a variety of approaches. They can take the form of a literal depiction, like a highly detailed and accurate botanical drawing, or they can be represented in a more abstract way, as in Georgia O'Keeffe's flower paintings. Use a stylized and modern approach when depicting florals, or consider simply focusing on the silhouette of the flower or plant. As you begin exploring different techniques for designing florals, you may be surprised to find that you prefer an approach that you may not have ever considered.

When designing a floral pattern, draw your inspiration from all parts of the plant. Consider not only the complete flower itself, but also be mindful of whether the flowers or leaves grow in natural clusters or if they are isolated on single stems. Pay attention to the details of the petals, the shapes of leaves, the curvature of branches and vines, and how they all come together. Think about the root structure of the plant and where it naturally grows as part of the landscape. All of these components can influence the specific direction you might take with your design.

Differing floral design styles can result in patterns that can evoke a wide variety of emotions. From sweet and romantic to dramatic and bold, floral patterns can provide designers with subject matter that has boundless opportunities for the creation of unique fabric designs.

ETHNIC MOTIFS

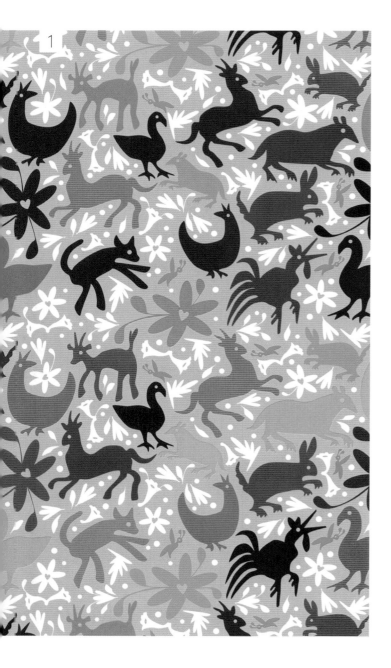

Patterns drawn from a specific culture are known as ethnic motifs. Worldwide, there are countless styles of ethnic designs and tribal art, each one unique in its own way. Traditionally, these designs were often created for their cultural significance or symbolism and celebrate some aspect of that culture's history. Over time, these design references to color, to pattern, or to subject matter continued to appear and became a part of the culture's design heritage.

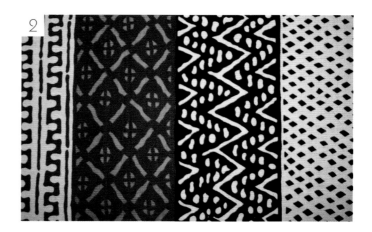

1 Animals depicted in the popular embroidery style found in Mexico. Mexico Springtime: United Love fabric by Samarra Khaja

2 Textiles from West Africa. ©iStockphoto.com/Peeter Viisimaa

3 Russian folk embroidery. ©iStockphoto.com/Svetlana Tikhonova

4 Graceful Geisha fabric from Michael Miller Fabrics

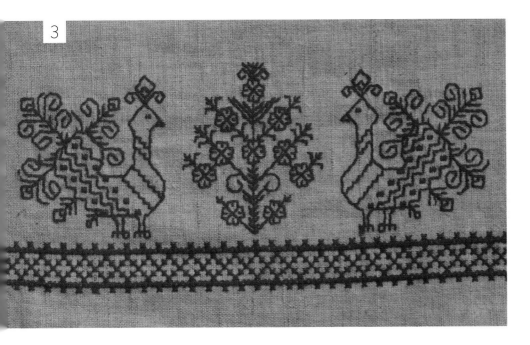

3

Although ethnic motifs are based on tradition, for a fabric designer there's a unique opportunity to blend tradition with a modern approach and create a new intersection of culture and design. When developing ethnic-inspired designs, stretch the boundaries and don't hesitate to infuse your own personal design style into what you create. Choose traditional colors or modify the palette to suit your personal approach. Identify individual design components that you particularly like, and amplify how they appear in your design. Your approach may be a more literal translation of a traditional ethnic motif, or it may simply be a subtle nod to the motif that inspired you. Ethnic designs often find their way into showrooms and runways, and are popular in apparel and home interiors.

4

CONVERSATIONAL MOTIFS

A conversational or figurative motif is defined as one that has recognizable objects (other than flowers, as they have their own category) in the motif. These designs can feature any object—from a pencil, to a rocket ship, to a chair—and anything can be used as the basis for a design. Novelty and juvenile prints are part of this motif, so have fun when designing these patterns. Your design subjects are limited only by your imagination. As a textile designer, this category may provide you with the opportunity for incorporating the widest variety of subject matter in your designs.

For me personally, conversational designs allow the most creativity in subject matter. My brain thinks in terms of objects and combinations, so this motif category is often the most natural for me when I am designing. Combining geometrics with bold graphics can add additional shapes and forms for visual interest, and provide flow between the objects in the pattern.

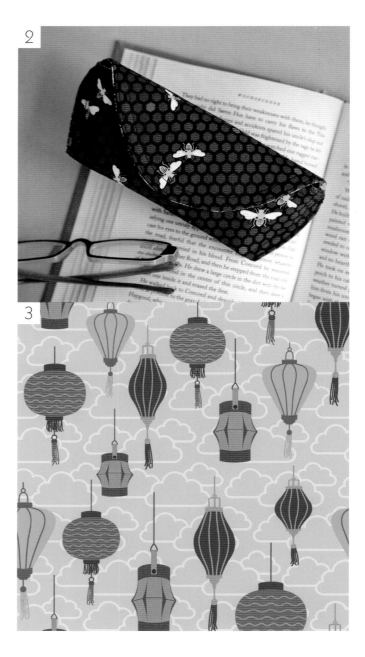

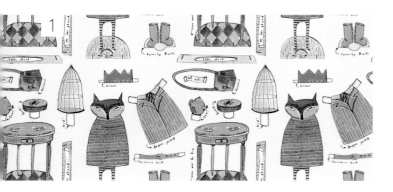

Toile

Toile (or toile de Jouy) is a type of conversational motif that often uses pictures of scenes from daily life. Traditionally, these patterns are printed on a white or off-white background with one single color (mustard, red, green, black, or blue) and depict a colonial or country scene. Toiles are complex and rich with detail and generally feature a large repeat in order to allow the eye to focus on the specific detailing and story being told in the pattern. But as with all designs, this traditional style can be fused with a modern approach to deliver a surprising result. Take, for example, the modern toile Nolita, by French design house Pierre Frey, which features the downtown Manhattan water towers. These iconic towers are an unexpected subject for a toile, but inclusion of these modern subjects, combined with the illustration style, result in a beautiful fabric that is appropriate for home décor or apparel.

Designing with a more graphically intense and decidedly tongue-in-cheek approach is Paul Loebach's pattern Yee-Ha featuring bucking broncos, oil wells, and cowboy hats. A playful jab at the icons of my native state of Texas, this pattern demonstrates a witty approach to reinventing a traditional favorite.

1 Meet Mr. Fox fabric by Mummysam

2 Eyeglasses case by Cherie Killilea, fabric by Patty Young for FreeSpirit Fabrics

3 Chinese Lanterns fabric by Patty Young for Michael Miller Fabrics

4 Nolita by Pierre Frey

5 Yee-Ha wallpaper by Paul Loebach

TEXTURES

Don't discount the value of subtlety when designing fabric. Although these textural designs may appear basic at first glance, their simplicity is part of their inherent beauty. In quilting, textures are often used as blenders to allow the showier prints to take center stage. When designing fabric, textures can also be layered as a background to provide depth for a print like a floral. They can also be very beautiful on their own, so spend some time exploring the different approaches to creating textured patterns.

1

Hash marks
Provide the effect of a loose grid of hand-drawn lines

Stippling
Uses small dots to create a pattern

Textile textures
The printed pattern mimics the texture of other textiles such as linen or silk

2

3

4

Marbling

Has the appearance of a hand-dyed fabric

Faux bois

From the French for "false wood," *faux bois* refers to patterns that look like wood grain

Tone on tone

Adds depth and dimension while featuring differing ranges of a single color

Brush strokes and streaks

These patterns look like they were painted with a brush

1 This purse by Marimekko uses a simple tone-on-tone print

2 Weave fabric designed and screenprinted by Lucie Summers

3 Sunshine and Shadows fabric by Jane Sassman for FreeSpirit Fabrics

4 Fiberweave fabric by P&B Textiles

5 Artisan Batiks: Prisma Dyes by Lunn Studios for Robert Kaufman Fabrics

6 Faux Bois: Brown on Brown fabric by Samarra Khaja

7 Aboriginal Dots fabric by Kaffe Fassett for Westminster Fabrics

8 Boutique Batiks fabric by P&B Textiles

REPEAT TYPES

In order for a design to be reproduced on fabric, it has to be laid out in a repeat that will allow for the pattern to come together in a seamless manner. A repeat is required for the design to reproduce over and over across the length and the width of the fabric. When creating your pattern, you can design in repeat from the very start, or you can complete your design and then put it into repeat after the design is finished. Learning to create repeats is a critical step in designing fabric. This section is a quick primer on the types of repeats, and we will delve more deeply into exactly how to create repeats in Chapter 3. There are four types of repeats: straight, brick, half-drop, and random/tossed.

Straight repeat

Images form a grid following horizontal and vertical lines

Brick repeat

Images are moved halfway horizontally to the next image

Half-drop repeat

Images are dropped halfway vertically to the next image

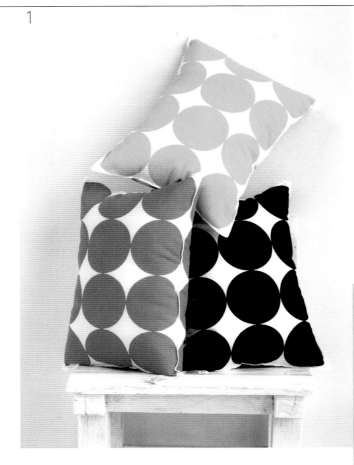

Random/tossed design

Images are randomly placed with no
discernable pattern

1 Cushions with fabric designed by Hitomi Kimura

2 Birdies and Chairs by Laurie Wisbrun for Robert Kaufman Fabrics

1

MIRRORING

To create a mirrored design, images can be flipped along the vertical or horizontal axis so that they face in different directions.

Horizontal mirror

Images face different directions along the horizontal axis (left to right)

Vertical mirror

Images face different directions along the vertical axis (up and down)

Random mirror

Images face all directions

COMPOSITION

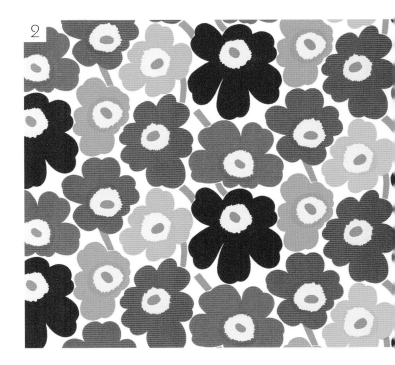

Once your design is in repeat, it's important to make sure that the repeat feels natural and that the overall design composition doesn't have unintentional gaps or channels between the elements. It sometimes can be difficult to spot these vacant areas when you are in the midst of designing, so it's always good to take a break and review your design later with fresh eyes.

Lineups
Unintentional alignment of images

Alleys
Linear gaps in the design

Holes
Inadvertent blank areas in the design

1 Woodland Damask, a horizontal mirror from Isabelle Kunz, Trois Miettes

2 Unikko poppy print from Marimekko

DIRECTION

Directionality in a design defines which way a pattern appears to be facing. A pattern can either be facing in a single direction, multidirection, or it can be an allover random (or tossed) pattern. Although single or multidirectional fabrics can often be the most visually pleasing, it is important to keep in mind how you envision the fabric being used. Traditionally, multidirectional or tossed fabrics are most often selected for apparel, as there is minimal waste when laying out and cutting a pattern, and matching of patterns at the seams is not a concern. As you design fabric work, try your hand at all of the directional styles.

Single direction

The pattern appears upright and all components are facing a single direction (either horizontal or vertical).

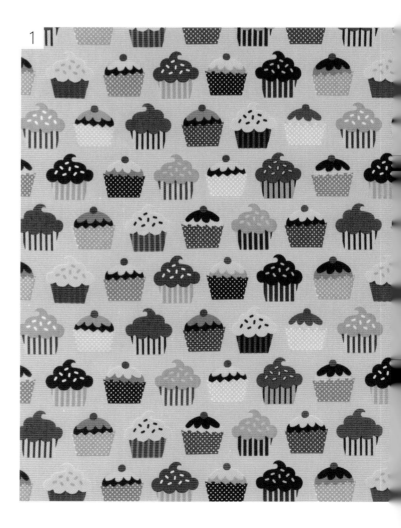

1 Confections fabric by Caleb Gray for Robert Kaufman Fabrics

2 California Dreamin' fabric by Jenean Morrison for FreeSpirit Fabrics

3 On a Whim 2 by Amy Schimler for Robert Kaufman Fabrics

Tossed

The fabric's pattern has no discernible right way up and can be cut in any direction. This style of fabric provides the most flexibility in use.

Multidirection

The pattern of the fabric is viewed correctly upside down or right side up.

Multidirectional stripes and patterns can be cut either with or against the bias, essentially creating multiple patterns from a single fabric.

SCALE AND LAYOUT DENSITY

Scale refers to the size of the print on the fabric. Generally, prints are divided into three scale categories: small, medium, and large. When creating your designs, try modifying the scale of the elements. You'll find that the same images can take on a completely different feel depending on how they are sized and spaced.

Low-density, small-scale print

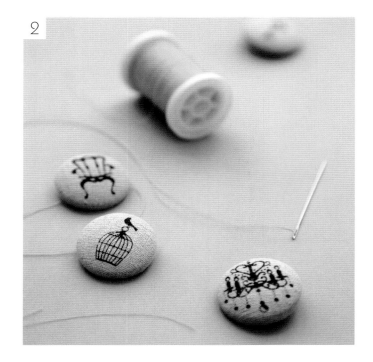

Prints can vary in density as well as scale. Density refers to how much ground (or space) is left between your design elements. Adding space between your elements may help emphasize the individual components of the design. Tightening the space between the elements may give your design more sense of movement.

High-density, large-scale print

High-density, small-scale print

1 Happy Hedgehog March small zipper pouch by Simbiosis

2 Petite Maison fabric-covered buttons by Claudia Corimer

3 Red Daffodil by Holli Zollinger

4 Garden Friends by Jay McCarroll for FreeSpirit Fabrics

5 Colorful Forest Coin Pouch by Jessica Blazek

PROFILE
Marimekko

1

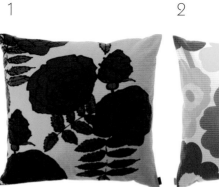

2

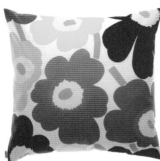

Known worldwide for its iconic designs, Marimekko was founded in 1951 in Finland and has long been a design leader known for its use of bold graphics, vibrant colors, and geometric shapes. In 1960, Jackie Kennedy purchased several Marimekko dresses and wore them on the presidential campaign trail, leading to a surge in U.S. sales and a boost in the popularity of the brand. Recently, the company's designs have experienced a renewed popularity and are influencing a new generation of fabric designers.

Marimekko has a rich history of designing modern and bold patterns. After being told by her boss that the Marimekko company would not design any floral pattern, Maija Isola, in protest over the restriction, designed a complete collection of florals in 1964—and the Unikko poppy print was born. Today, Unikko still remains one of the company's most famous patterns and has appeared on a broad spectrum of goods. Isola's modern approach to rendering florals resulted in a timeless pattern. Her daughter Kristina Isola continues to expand on the poppies design with unique and lush color stories.

3

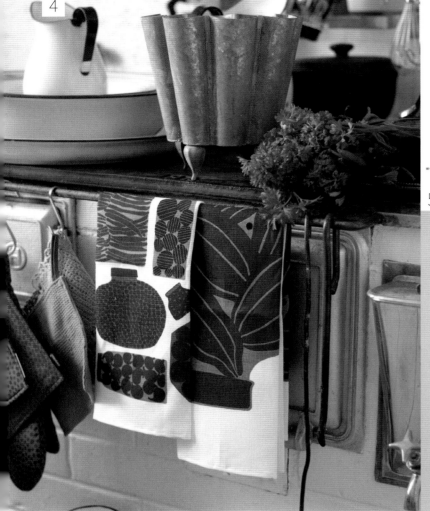

5

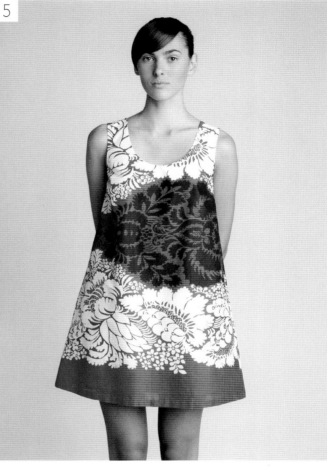

In 2008 the company's designs were used by Swedish fashion label H&M in a Marimekko tribute collection of men's, women's, and children's clothing. Featuring the bright, bold colors and some of the Finnish company's most memorable prints, the collection was a cornerstone of H&M's Summer 2008 line.

Today, Marimekko keeps expanding on its rich design heritage and continues to set trends in modern textile design. Those designs now appear on apparel, wall coverings, textiles, bags, and a wide variety of home décor and personal accessories.

1 Boldly patterned Ruhtinatar pillow from Marimekko

2 Unikko floral poppy print

3 Geometric pillow shams in Pillsirkku from Marimekko

4 Kitchen linens in the Purnukka pattern

5 A-line dress from Marimekko featuring a modern floral on silk

COLOR WHEEL BASICS

When designing fabric, it's helpful to understand a bit of basic color theory when you're considering which colors to use in your designs. The color wheel is a simple tool that shows the relationship among colors. Understanding how these colors relate to each other may make it easier to make your color choices work for your designs.

There are six basic colors on the color wheel: red, orange, yellow, green, blue, and purple. Colors that are in between the basic colors are the mixes or blends of the basics.

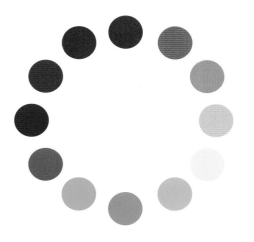

Primary colors

These are the base colors for all the other colors on the wheel and are the most vivid: red, yellow, and blue.

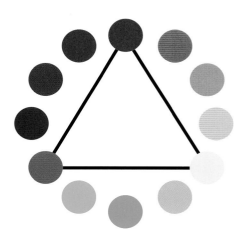

Secondary colors

When two primary colors are mixed together, secondary colors are created. On the color wheel, each secondary color is placed between the two primary colors that were blended together to create it: orange, green, and purple.

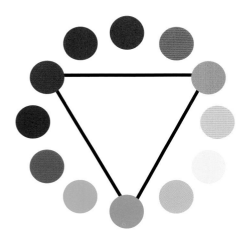

Tertiary colors

When a primary and a secondary color are blended together, tertiary colors are created: yellow-orange, red-orange, red-purple, blue-purple, blue-green, and yellow-green.

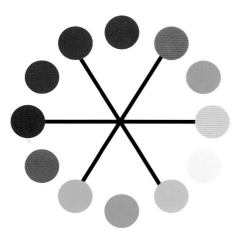

COLOR SCHEMES

Analogous

These are colors that "match" well and have low contrast. When working with analogous colors, be mindful of selecting a range of colors that have enough contrast to be differentiated from one another.

Ed Wisbrun Photography

©iStockphoto.com/Douglas Allen

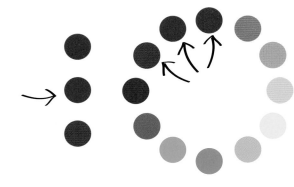

Complementary

When designing for heavy contrast, select colors that are directly across from each other on the wheel.

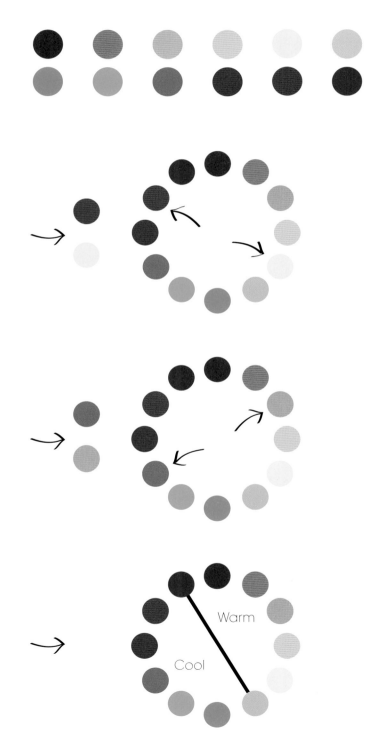

Another method of grouping complementary colors on the color wheel is to divide them into warm and cool colors. Warm colors are brighter and more energetic, and cool colors are generally softer and more soothing. White, black, gray, and brown are considered to be neutral.

Warm

Cool

Triadic

A triadic color scheme uses colors that are evenly spaced around the color wheel. A triadic combination does not have the same level of contrast as a complementary scheme, yet looks very balanced.

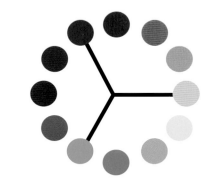

ADDITIONAL DEFINITIONS

Tint and brightness

Adding white to a color changes the tint.
The more white a color has, the brighter it is.

Shade and value

Adding black to a color changes the shade.
The more black a color has, the darker its value.

Tone and saturation

Adding gray to a color changes its tone. The more gray a color has, the more desaturated and less vivid it is.

COLOR MODELS

If you've ever created a digital design, and what you see on your computer screen is different from what you print out, you've directly experienced the challenges of different color models. These models are completely separate from the color wheel, so set aside what you've learned about the color wheel for now. Understanding the basics of color models will help you when you are viewing your designs on your monitor and then preparing your files to be printed.

RGB color

This is what your computer monitor uses. Even if you have your colors set to one of the other models, what your monitor is displaying is RGB.

CMYK color or process color

Achieved by overlapping different percentage values of four colors (Cyan, Magenta, Yellow, and Black) in color printing.

Pantone (PMS) colors

The Pantone Matching System is a standard color system used by printers to be able to reproduce CMYK colors in a consistent manner. It can be especially useful when discussing a color change with a printer to refer to a PMS color to provide you with a consistent basis against which to match color. For instance, instead of saying, "It should be more robin's egg blue," you might say, "It should be PMS 317."

LAB colors

LAB is a model based on how the human eye actually sees color. The model is based on an intersection of lightness/brightness, red/green, and blue/yellow based on scientific work from the 1930s.

We'll dig deeper into color models, preparing your files for printers, and adjusting for printing color gamuts in future chapters.

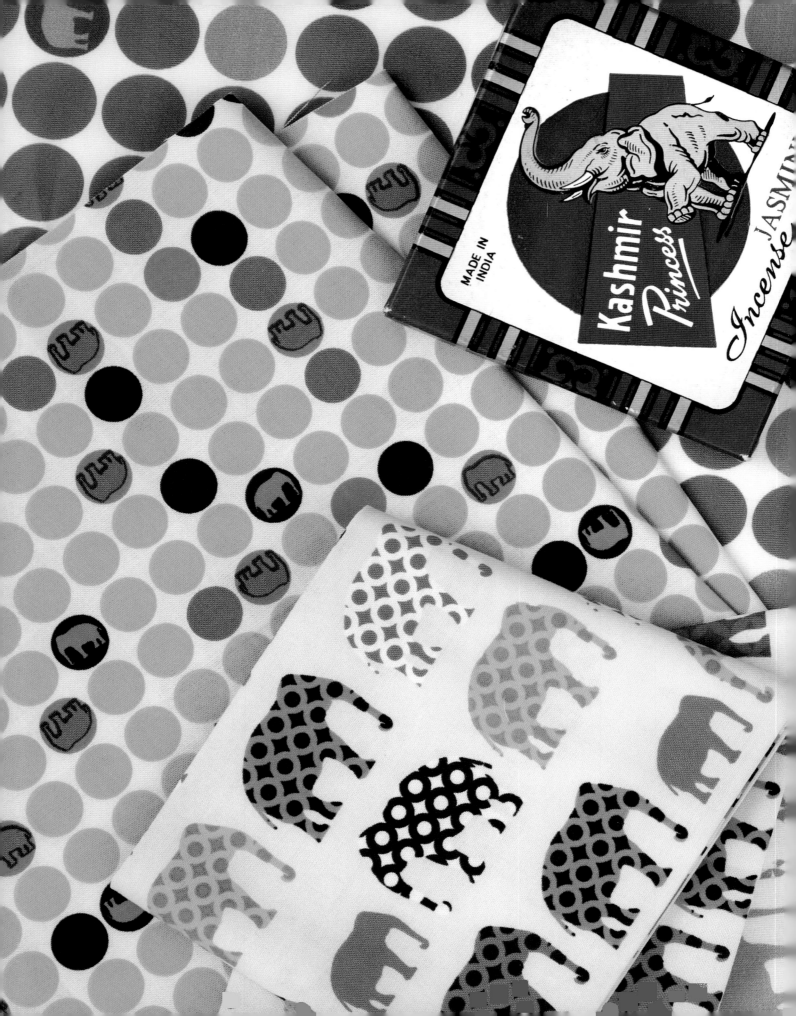

CHAPTER 2
SOURCING INSPIRATION

Beautiful imagery and patterns are everywhere, and learning how to be inspired by what you see and how to incorporate trends is an important aspect of designing fabric. This chapter will help you understand what's okay—and what's not okay—to use in your designs.

Inspiration for the Urban Circus elephant pattern by Laurie Wisbrun

LEGAL CONSIDERATIONS

As a designer, it's very important to understand the concepts of copyright, usage licensing, and the rules governing images in the public domain. When designing fabric, you may not want to—or be able to—create all components of your design. In those instances, you may decide to source portions of your pattern. Generally, when images are sourced, you will not be able to use the designs to sell the fabric commercially, nor will you be able to make a product to sell that uses that fabric. But if you are looking for artwork to enhance patterns that will be solely for your individual use, sourced imagery may be a good alternative for you.

There are a variety of companies and sources that offer art that you can incorporate into your work. There are so many beautiful images available in the public domain that you can leverage for your designs. I'm not a lawyer, though, so make sure you read closely any licensing information provided by whatever sources you use for your art. If you don't, you could be in violation of copyright law, which might lead to an unpleasant letter from a lawyer!

Copyright

Copyrights give artists ownership of their designs. This ownership provides some level of protection for the copyright owner around unauthorized use of a design. As copyright owners, artists have the exclusive rights to reproduce and exhibit their work in any way they wish. Copyright ownership also provides the owner with the right to create derivative works based on the original work. So what's a derivative work, you ask? A derivative work is created when the artist takes the original image and then modifies it or incorporates it into another medium like a calendar, note cards, or coffee mugs. Copyright law is quite complex, so it's something worth exploring in more depth if you plan to use sourced imagery.

For more information on copyright visit:
U.S. Copyright Office: *www.copyright.gov*
European Union Copyright Office: *www.eucopyright.com*
Australian Copyright Council: *www.copyright.org.au*
Canadian Intellectual Property Office: *www.cipo.ic.gc.ca*

Public domain

A work that no longer falls under copyright protection is part of the public domain. When a copyright expires (generally 70 years from the death of the author or 120 years from the date of the creation, depending on the country where the copyright was filed), the image passes into the public domain, which means it can be used without seeking a license for publication. It is your responsibility to research an item's copyright before you decide to use it. It should be noted, though, that when an image from the public domain is incorporated into a design, the resulting design can't be copyrighted without significant modification of the image from the public domain or incorporation of that element into a much broader design.

Royalty free

If a piece of artwork is royalty free, that does not generally mean the image can be used without paying for it. It means when an image is purchased, the image can be used multiple times without paying the owner of the image a royalty fee every time the image is used.

When a royalty-free image is purchased, the licensing agreement will specify the allowable uses for the image. It may include specifics about where, when, or how the image can be used. Some licensing agreements will allow you to use the image only if it's being used for personal use. So even if an image is royalty free, you likely cannot use the image as part of a design you plan to create for commercial purposes. In other words, you would be able to use the image to create fabric for your own personal use but you could not use that design in fabric or products that would be sold commercially.

SOURCING FROM VARIOUS MEDIA AND VINTAGE SOURCES

If you're creating designs for your own personal use, there are a plethora of places from which you can source images. When sourcing a digital image for fabric design, it's important that the image is of high enough resolution that it doesn't look degraded when it's printed on fabric. As a general rule of thumb, an image should be at least 150 ppi (pixels per inch) if you plan to scale the image size down to be printed, and preferably 300 ppi if you plan to print the image at the actual size.

CDs

Try your local bookseller for digital collections of clip art. The art contained in these CDs is generally royalty free and in high resolution, so you can scale the images to meet your needs.

Online stock

There are a variety of online sites that allow you to search a vast collection of photography and illustrations for royalty-free stock. A few sites to try are:

www.istockphoto.com
www.shutterstock.com
www.sxc.hu
www.gettyimages.com
www.doverpublications.com

Printed clip art books

Although the images from clip art books are often not available in a digital format, they can be scanned and incorporated into your personal (again, noncommercial) designs. Clip art books can also serve as wonderful inspiration to give you insight into different illustration styles or subjects.

Library

Alternatively, you can take advantage of the online databases many libraries offer, such as the New York Public Library's Digital Gallery. This wonderful source for imagery contains thousands of images digitized from the Library's vast collections of maps, posters, photographs, and illustrated manuscripts, which you can either search or browse by category.
www.nypl.org

1 This illustration was sourced from the New York Public Library and put into a half-drop repeat and printed on an organic cotton sateen. "Le Lièvre, Le Lapin Sauvage, Le Lapin Domestique" from Oeuvre complètes de Buffon, published by Pauquet frères, 1829–1832

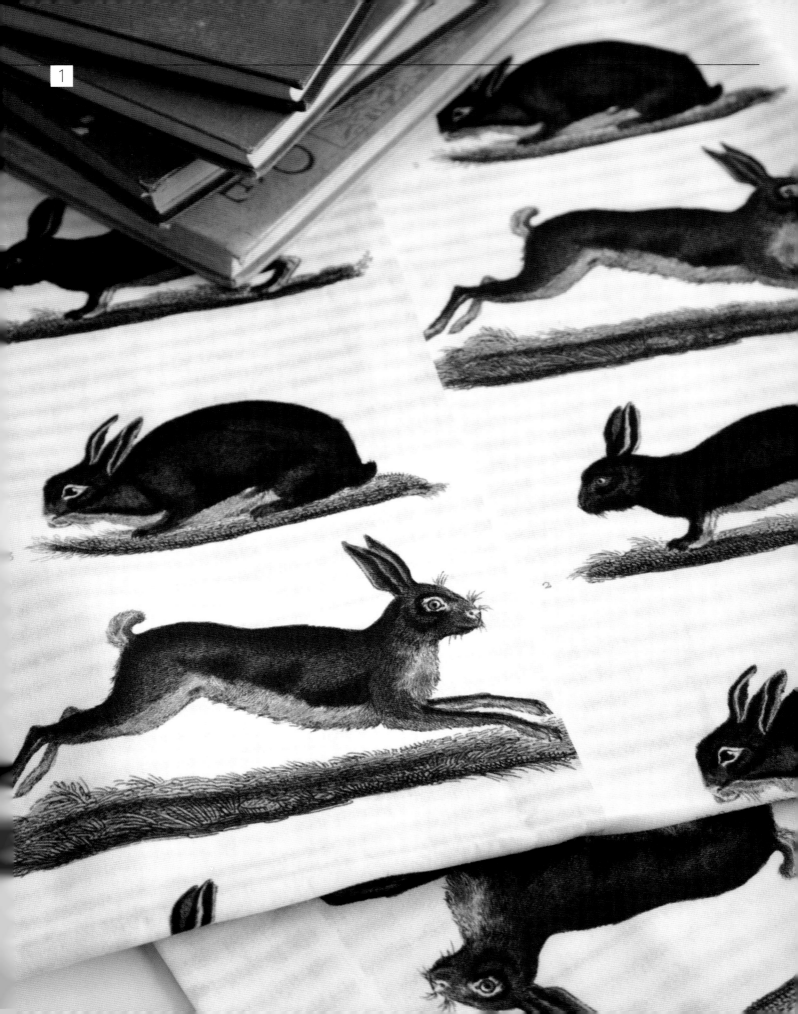

INSPIRATION VS. PLAGIARISM

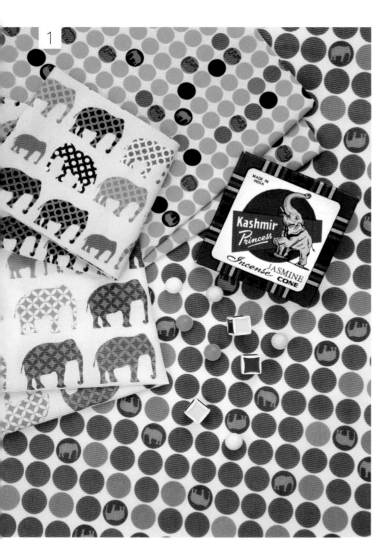

1

Although the line between inspiration and plagiarism may be hard to define, make no mistake. Inspiration is something that motivates you to create. Plagiarism is stealing someone else's idea.

It's part of human nature to absorb what you see in your daily life and be influenced by what you encounter. Sometimes you are inspired by something when you are actively seeking design ideas, while at other times, inspiration happens subconsciously without you even realizing that it's occurring. Never sell yourself short and copy someone else's work. Inspiration doesn't always come easily, but it's an absolutely necessary part of the creative process. Innovation is a crucial ingredient for originality. You should be inspired by other designers and by art that you encounter, but copying someone else's work is stealing. Not only is it likely that you will be caught eventually if you put your designs in the public domain, but also, you cannot be proud of a design you have stolen. Constantly challenge yourself to be original so that you can be proud of everything you create.

Make sure you're creating your own design as you reinterpret a subject with your personal style and approach. Simply changing the colors or scale of someone's design doesn't qualify as reimagining the work to make it yours. If you ever find yourself tempted to copy someone's design, imagine what it would feel like to have someone copy something you worked hard to create. Not so good, eh?

1 Be inspired by what you encounter and translate that inspiration into designs based on your personal aesthetic

KEEPING INSPIRATION JOURNALS

As a designer, it's likely you carry a sketchbook or notepad in your bag. And if you don't, I hope you'll start. Inspiration can come to you throughout your day, and it's a good idea to build the habit of capturing inspirational ideas as they appear. Creative ideas can be fleeting, so it's important to capture them in the moment. Anything can spark an inspirational idea. Fine art, architecture, song lyrics, a passage from the newspaper, a beautifully prepared meal, your natural surroundings—they are all rich with possible design inspiration.

Don't worry about structuring your journal into a neat and tidy format. Your journal should simply be a way for you to quickly jot down ideas and thoughts that you might incorporate into a design. If you're a person who doodles, these quick sketches will likely find their way into your journal and perhaps become the basis for a new design.

In addition to my journal, I often carry a camera. As my hand-drawing skills are somewhat unpolished, it's often difficult for me to quickly sketch whatever has inspired me. But with a camera, it's a literal snap to capture my inspiration. I have a general "inspiration" folder on my computer where I store these randomly collected photos. When I am ready to start cataloging my ideas into mood boards, I know exactly where to go to pull from.

In addition to my inspiration journal, I have a box in my studio where I store found objects, photos, and images torn from magazines and catalogs. Instead of holding on to magazines filled with dog-eared pages and then months later not remembering what inspired me in the first place, I prefer to simply tear out anything that strikes me as a possible design inspiration and stick it in the box. When the box starts to get full (or I'm in the mood to catalog), I begin to build collage pages using goodies from my box and pulling ideas from my inspiration journal and inspiration photos on my computer. These collage pages are often the precursor to building a full-scale mood board.

BUILDING MOOD BOARDS

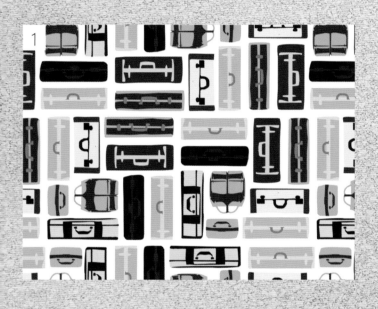

If an inspiration journal is a less structured approach to cataloging ideas, a mood board is a way to organize your inspiration to set the stage for a design. Mood boards are a way to begin to tell the story of the design you're planning on creating. A mood board can help you clarify the "big idea" for a design and pull together imagery and ideas in a more definitive way.

When I'm starting a new fabric collection, I'm like a pack rat, collecting bits and pieces to help me clarify my thoughts. I often have a big idea in my head, and I'll build a mood board to help me flesh out my color stories and the feelings I want my designs to evoke, as well as identify possible iconography to include. A lot of the time, when I go back and compare my finished design to my initial mood board, there is a very clear correlation between the board and the design. But my creative imagination can be sparked by some very small piece of my mood board, leading me to design something very different from what I'd originally conceived. Those small creative sparks often lead to my favorite designs, so listen to your creative self, and if your design begins to diverge from a mood board, then follow that path.

That is, of course, unless the mood board has been provided by clients as a way for them to communicate the type of design they are seeking. In those instances, review every aspect of the board closely, as each element was very deliberately included as design guidance.

Mood boards can be structured in a variety of ways. They can range from a simple digital collage to a very complex physical board loaded with pushpins and goodies.

1 This Suitcase fabric was created after drawing inspiration from this mood board

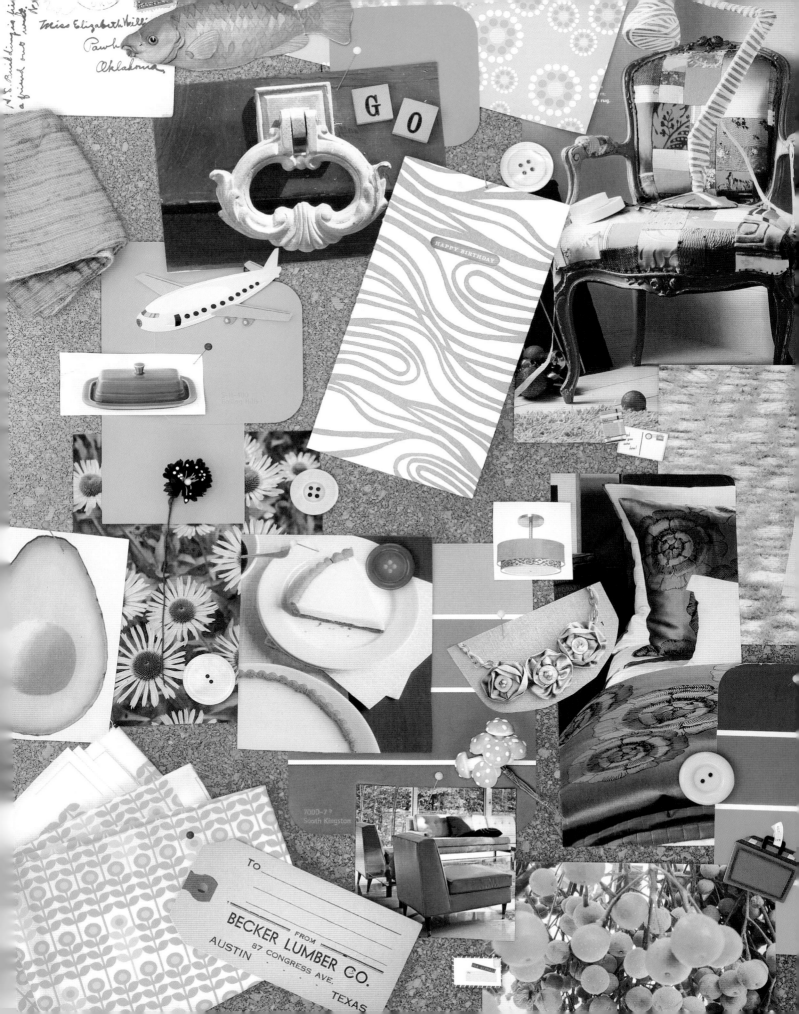

1

Digital mood boards

There are also a variety of free online tools available to
help create digital mood boards. These websites let you
choose from a variety of photos to create your own digital
collages from fashion and décor images. Several of the
sites also have an extensive library of saved collages
and boards created by other users. They're rich with
opportunities for inspiration and, best of all, they're free!

Polyvore

www.polyvore.com

Filled with fashion images from all over the Web, this
site lets you choose from thousands of fashion and décor
pictures to create your own style collages. The drag-
and-drop "virtual styling" tool makes learning to use the
site quick and easy.

Mosaic Maker tool from Big Huge Labs

www.bighugelabs.com/mosaic.php

My personal favorite is the Mosaic Maker tool. It allows
you to choose from photos on your local computer or
from an online site like Flickr and create tiled mosaics.
You determine the number of squares, specify the
spacing between the squares, and define the background
color. All you have to do is either upload your photos or
paste in URLs from a website and then push a button.
The mosaic is automatically created and you can save it
on your computer. The tool also creates HTML code
you can copy and paste that includes links and credits
for all the photos in your mosaic. Beware . . . this one
is addictive!

COLOR AND TREND FORECASTING

What hot new color combination will grace the runways and showrooms next year? Will tribal-inspired designs still be hot next season? These are the types of questions that color and trend forecasting can help shed some light on. As a designer, it's important to stay abreast of the trends and color combinations that will be popular in upcoming seasons in apparel and home décor. If you design your patterns to leverage or complement these trends, it may help make your fabric designs more marketable.

However, forecasting services can be expensive. To get to this type of information on the cheap, you can try these free or inexpensive sources on the right.

Color forecasting: annual or semiannual reports

www.colorassociation.com

www.pantone.com

www.colormarketing.org

www.sherwin-williams.com

www.sico.ca

www.valspar.com

www.behr.com

www.globalcolor.co.uk *(free monthly e-newsletter)*

Interior design trends

www.elledecor.com

www.trendhunter.com

www.apartmenttherapy.com

www.designsponge.com

www.decor8.com

printpattern.blogspot.com

www.dwell.com

Fashion design trends

www.wmagazine.com

www.style.com

www.vogue.com

www.stylebubble.typepad.com

www.thesartorialist.blogspot.com

1 A photo mosaic of home décor images can help you set the mood for a new design

INTERVIEW
Josephine Kimberling

Josephine Kimberling is a licensing artist who has been creating surface pattern, artwork, and design solutions in-house for industry leaders in the fashion, greeting card, and gift-wrap industries for more than ten years. Her art-licensing brand combines her love of creating patterns and delicious color stories with the many different types of products she has a passion for. *www.josephinekimberling.com*

Q: How do you keep up with trends?

A: I find that keeping my eye on trends by reading fashion, home décor, art, and design magazines, and blogs keeps my eye fresh and adaptable to forward thinking. I try to keep my mind open when reviewing forward information and not shut something down because it's not a personal preference of mine. That's where innovation and new ideas can spark. I spend a lot of my time researching. With my background in fashion, my first source for scouting trends is to review runway collections, since fashion is on the fast track of the trend spectrum.

Q: How do you incorporate trends into your designs?

A: I use trends as a guide and launching-off point for a theme. For example, if 1960s florals are in, then I'll create a group around that theme. I develop my own interpretation of that theme and create artwork with my style and point of view. I really enjoy modern-eclectic and feminine mixes in my work, so while a theme may be a trend, I still like to put my own spin on it and incorporate other elements that make that theme truly me.

Q: What types of patterns are your favorites to design? Why?

A: I really enjoy designing florals and ethnic-inspired prints such as medallions and paisleys. Patterns with detail are my cup of tea! I love trying to think of new layouts and concepts around floral prints, and I also enjoy discovering new types of flowers to draw from … although I do have favorites, such as peonies, dahlias, poppies, daisies, mums, and zinnias.

Another type of pattern I enjoy designing is one with an allover feel. I enjoy the challenge of aesthetically making a pattern work and flow across a repeat. This is mostly from my textile and fashion background, because there it's usually important to create designs that do not have a distinctive repeat when being worn on the body, so your eye can flow across the garment—unless of course that's the point of the design.

1

2

1 Flower Chain for Robert Kaufman Fabrics

2 Primp for Robert Kaufman Fabrics

3 Glam Garden fabric collection for Robert Kaufman Fabrics. Photography by Natalie Grimmer of natalie g. | photography www.nataliegphotography.com

4 Hot Blossom fabric collection by Josephine Kimberling for Robert Kaufman Fabrics. Photography by Natalie Grimmer of natalie g. | photography www.nataliegphotography.com

Q: When you're suffering from a lack of design inspiration, what do you do?

A: When I find myself in an inspiration rut, there are a few things that I do depending on how I'm stuck. First, I may stop what I'm doing and do something different for a little bit to loosen myself up and to come at something with a different perspective. I will usually get out of the house and do something I enjoy—such as shopping—to get my mind off things and de-stress.

Another option is to go into inspiration research overdrive, where I will set aside a good chunk of time to research online, go through my personal book collection and inspiration binders, or go to a bookstore, while allowing myself to do so without any rules. I will check out sites that I usually don't frequent, and get lost in the Web by clicking links and links and links. I may even start to develop a themed inspiration board to visually capture my inspiration and give me a focus.

Q: What do you find the most challenging about designing fabric?

A: Working in collections is a new thing for me, which I quite enjoy. The most challenging thing for me to do is to create simple patterns that support the main prints in a collection because I enjoy creating complex designs the most.

Q: And what do you find most rewarding?

A: The most rewarding thing about designing fabric is being able to make something out of it and to see others do the same! The quilting and fabric industry is really full of some amazing and down-to-earth people.

Getting ready for a collection launch is also so rewarding to me, because I feel it allows me to tell the complete visual story of that collection, from start to finish, and to be able to share it with everyone. With that, when a collection is getting ready to come out, I love receiving the sample yardage and having the fabrics in hand so I can mix them together and see how the colors, patterns, and sizes can work in different ways.

4

CHAPTER 3
DESIGNING PATTERNS

So you have an idea for a fabric design. But how do you take that idea and turn it into a pattern? This chapter is filled with tutorials and practical tips to teach you how to take your design elements and turn them into patterns that will work for printing on fabric.

Nesting Chairs collection by Laurie Wisbrun

GENERAL PATTERN DESIGN TIPS

Your inspiration research is complete, and you have a general idea of what you're going to create. You've researched trends and have a clear idea of what your color story will be. You've created a few design elements either on your sketch pad or digitally. Now you're ready to start creating your textile patterns. As you begin designing, here are a few tips to keep in mind.

How will your fabric be used?

The end usage can affect how you arrange your design layout and how you size your elements.

Apparel

Design size is generally smaller so it can be easily made into garments with patterns that flow seamlessly across the body.

1

1 Harvest Bohemian Dress, clothing and photo by Melissa McKeagney

2 Upholstered chair by Sultan Chic

3 Country Fair fabrics by Denyse Schmidt for FreeSpirit Fabrics

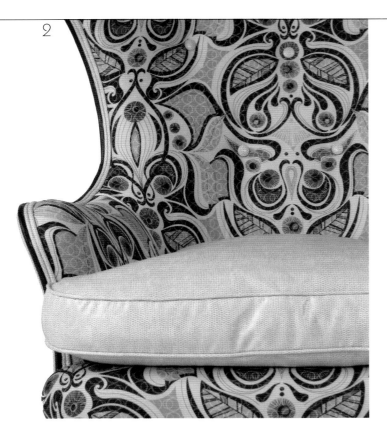

Interior décor and upholstery

As a general rule, larger design elements are more suitable for covering sizable areas like furniture or draperies. But rules are meant to be broken. Smaller elements can create a tailored look, for example.

Quilting and craft

When designing quilting and craft fabric, I generally create complete collections. As a quilter and crafter, I appreciate having coordinating fabrics from a color story that cover a gamut of sizes:

- Large-scale pattern
- Mid- and small-scale patterns
- Coordinating textures or stripes

Modify components

- Layout and direction—the arrangement of design elements
- Scale and density—size of elements and distance between components
- Color—the palette for your designs

Break the rules

- Try combinations of elements that don't necessarily "go" together
- Play with colors that are outside your usual palette
- If you're used to designing small, intricate designs, try something large and more free-form
- If you usually migrate toward florals, try something geometric
- Play with mirroring for a new effect

And most important, just have fun!

TOOLS:
ADOBE PHOTOSHOP AND ILLUSTRATOR

The tutorials in this book use Adobe Photoshop CS4 and Adobe Illustrator CS4. Although these two software packages are widely used in the graphics industry, they are certainly not the only tools available (see page 201 for more options).

Before we explore the differences between the two types of software programs that will be most helpful to you for textile design, it is important for you to understand the difference between the types of digital images. All digital images are either vector-based or bitmap-based. The primary difference between the two types of files is in the way a computer handles each file type.

Bitmap files

Bitmap images (also known as raster images) are made up of pixels. Each pixel in a picture is an element or a tiny dot that makes up what you see on your monitor. These types of files are best suited for photographic-type images with complex color variation.

Each pixel in the image is mapped into a grid that is based on the image's resolution. A bitmap-based image of 1 × 1 in/2.5 × 2.5 cm with a 300 dpi (dots per inch) resolution would be contained in a grid of 300 × 300 pixels.

Bitmap images are resolution-dependent. As such, they are not easily enlarged, and when scaled up in size, the edges lose their sharpness and look jagged (pixelated).

Vector files

Vector-based images generally contain well-defined elements such as curves and shapes of various colors. Each element is defined mathematically by the computer, and by using nodes or handles along the edges of an object, it can be easily manipulated and reshaped. These types of files are best suited for illustrations. Because these files are not pixel-dependent, a vector file can be increased and decreased to any size and the edges will remain sharp.

And then to further complicate the issue, there are files that contain both bitmap *and* vector data. These files are called *metafiles*. This could be a vector file (e.g., an illustration of a couch) that has a bitmap pattern applied as a fill (e.g., the floral pattern applied as the upholstery pattern on the couch).

TOOLS:
SCANNER, DIGITAL STYLUS, AND TABLET

If you decide to digitize any inspiration pieces that you've collected, there are two tools that you will find invaluable: a scanner and a digital drawing tablet.

Scanner

- Basics: A scanner digitally renders an image in dots per inch (dpi). Also known as ppi (points per inch).

- Resolution: To allow the most flexibility with the possible uses for an image, I generally scan at 300 dpi. This means I'll always have a high-resolution image available.

If your computer has a hard time handling very large files or you have limited disk storage space, an alternate approach is to scan the item using the resolution at which you'll be outputting the file. For instance, if you know your fabric printer requires images at 150 dpi, you can simply scan your original image at 150 dpi. The only downside is that if you plan to reproduce your image at a physically larger size than that at which it was originally scanned in, when you scale the image up, it may get pixelated (meaning you would start to see all the dots and it would look blurry). In other words, if you're scanning a small leaf and plan on printing it at 10 times its natural size, make sure you scan the original at the highest resolution possible to give you the most flexibility.

- Uses: Scanners can be used to digitize two-dimensional objects like photos and drawings, and three-dimensional found objects like dried flowers, grasses, leaves, strips of lace, buttons, or coins.

- Caution: Be mindful of copyright when scanning imagery. All the same copyright rules apply. Scanning an image from paper into a digital format does not change copyright protection laws. Make sure you are either scanning only your own artwork or that you are using images in the public domain that are copyright-free and licensed for your intended use.

Digital stylus and tablet

- Basics: A digitized pad that plugs into your computer with a stylus (digital pen) that allows the user to draw and paint digitally. The tablet provides more efficient movement than a mouse and more closely mirrors the control you would have using a pen, pencil, or paintbrush.

The tablet I choose to use is the Wacom Bamboo Fun. For me, it provides a large drawing surface, and the pen is comfortable to hold and intuitive to use. There are a wide variety of other brands and models with varying features and price points, so try out a few and find the one that works best for you.

PAPER-CUTTING REPEAT

It should be known that I can barely draw a straight line using a pencil and paper. I create all of my art digitally. So I was pleasantly surprised when I discovered how easy it is to create a repeat using the traditional paper-cutting repeat method. Trying out a new way to create a repeating pattern is a fun way to stretch your boundaries if you're accustomed to working digitally. And if you have yet to take the digital plunge, this is a wonderful way to understand how to create a repeat by hand. Once you've created your pattern, you can scan it so you have access to it electronically where the design can be edited and manipulated to your heart's content.

Supplies

- Paper
- Pencil
- Eraser
- Masking tape

1 Begin with a blank piece of paper.

2 In the middle of your sheet, draw your design. Stay away from the edges of the sheet.

3 Turn your sheet over and draw a four-part grid. Write the numbers 1 to 4 as shown.

4 Turn your drawing over and cut it in half vertically. Turn it over again so that the numbers are showing and tape the pieces back together as shown.

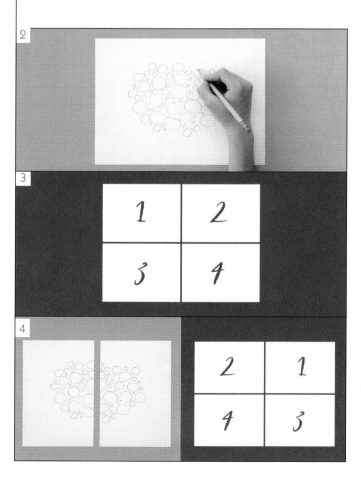

5 The middle of your drawing is now blank. Fill in the space but stay away from the top and bottom edges.

6 Un-tape the drawing and tape it back together as shown. It will be in its original configuration.

7 Cut your sheet in half horizontally and tape your pieces together as shown.

8 The middle of your drawing is blank again. Fill in the space but stay away from the left and right edges.

9 Turn your drawing over and tape your pieces back together as shown.

10 Your repeat is complete. Your next step is to scan the image, make any small edits, and prepare the file for printing (see Chapter 6).

11 This fabric, printed using www.spoonflower.com and embellished using embroidery thread, will make a lovely pillow cover.

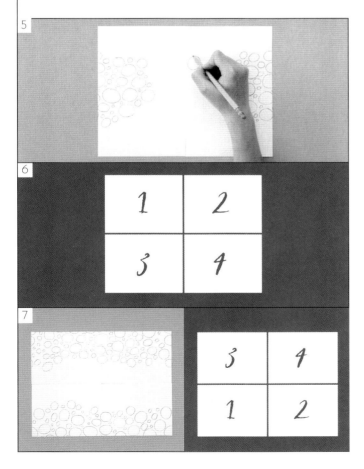

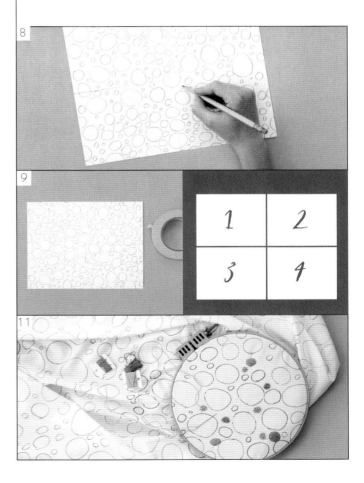

USING YOUR SCANNER

Using your scanner is another way to create a digital pattern. For this tutorial I used a scrapbooking paper punch to create my shapes, glued them to a page, and then scanned my pattern using a scanner. You could also use things like ribbons, buttons, leaves, or other found trinkets and follow this same process.

Supplies

* Colored or patterned paper
* Scrapbooking paper punch or scissors
* White paper
* Glue stick
* Scanner

1 Start by creating your shapes using your paper punch.

2 Create your pattern by laying out your shapes on a sheet of paper that will fit in your scanner.

3 Since you are creating a repeating pattern, make sure a few (but not all) of your shapes go up to the edges of the page.

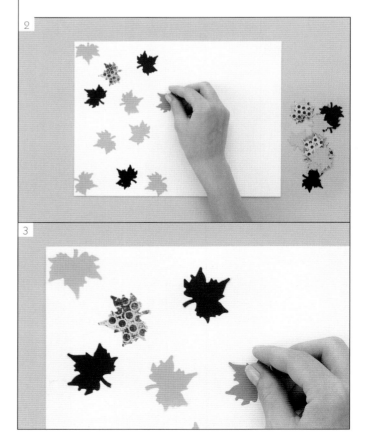

4 Once you're happy with the arrangement, add a small dab of glue from your glue stick. Use just enough glue to hold everything in place, but not too much so that you can still move it if necessary.

5 Place your sheet into your scanner. Make sure it's sitting straight.

6 Scan your sheet. My scanner has settings for color or black and white, and dpi, so I've scanned it at the highest resolution possible.

7 Once the file is in your computer, open it and check to make sure you're happy with the way it scanned. If you need to make any small edits, see Chapter 6.

8 I used www.spoonflower.com to print my fabric, and it recommended 150 dpi, so I saved my file at that resolution.

9 Upload your file.

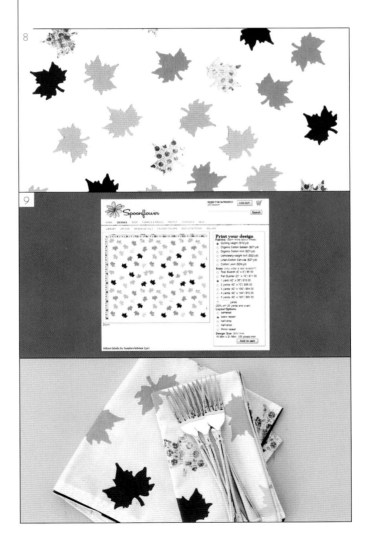

BUILDING A DIGITAL COLOR PALETTE

About the software tutorials in this book

The tutorials in this book are written to provide the beginning fabric designer with the basic skills needed to design and manipulate patterns digitally using Adobe Illustrator CS4 and Adobe Photoshop CS4. Adobe product screenshots in this book are reprinted with permission from Adobe Systems Incorporated.

What you will learn
- How to define a color palette using a photograph
- How to set color swatches

Software used
- Adobe Illustrator

Open your photograph in Illustrator

1 There are a myriad of inspiration sources for color stories. One wonderful source is to pull from photography. This photo of an old table made with wood scraps is filled with lovely shades of greens, aquas, and creams that would translate beautifully to textiles.

Isolate the colors in your photograph

2 Open your file. Select>All.

3 Object>Create Object Mosaic.

4 A box will open and you can select the number of tiles you would like. I chose 20 × 20, as that provided me with a variety of colors. Your photo may need more or fewer tiles to show all the colors. Click OK.

Select your colors

5 Your tiles will be grouped together. To select them individually, you need to ungroup them. Object>Ungroup.

6 Now choose the colors you want to add to your palette. Select the Swatches menu.

7 Select colors from the grid and drag them into the Swatches box. Any colors that you drag into the box that you decide you don't want can be dragged on top of the Trash Can icon and they'll be removed.

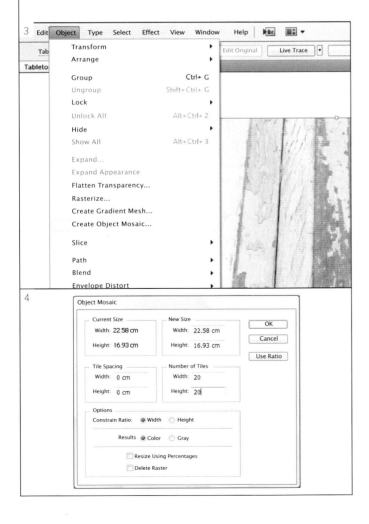

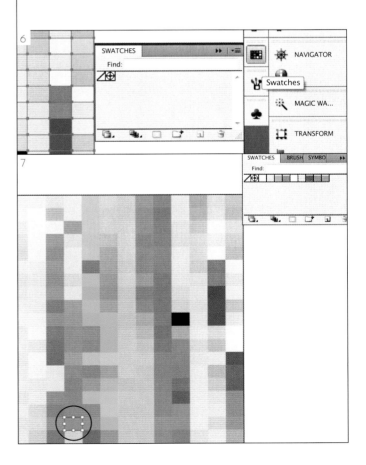

Create swatch

8 Click on the icon of the arrow with the lines in the top right corner of the Swatch box.

9 Select Save Swatch Library as AI and give your Swatch Library a name (I've called mine Seafoam), then click Save. You have now created a saved Swatch that you can use in any future design.

Test swatch

10 To see how to use your Swatches, we'll create a new file. File>New.

I generally work in a 8-×-8-in/20-×-20-cm tile. If you are creating a larger repeat, you will need to adjust accordingly. Click OK.

11 In the Swatch box, click on the top right corner. Open Swatch Library>User Defined. You'll see the Swatch Library you saved in step 4. Select it from the list.

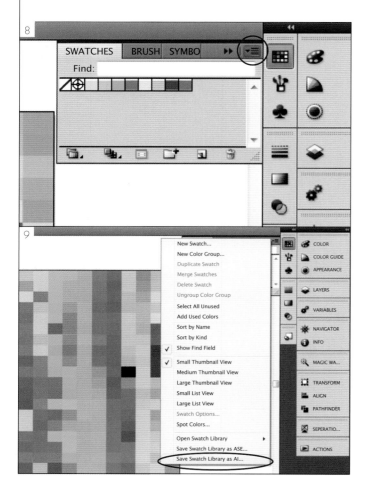

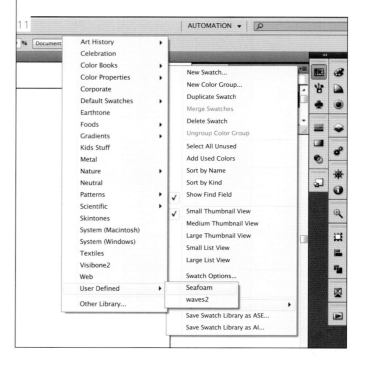

12 Your saved Swatch will now appear in the Swatch box. If you're using a Mac, the saved Swatch will appear in a separate palette.

13 Select the Rectangle Tool and create a series of boxes. For each box choose a Fill color from your Swatch box.

Now you can see how your colors work together using your saved Swatch Library.

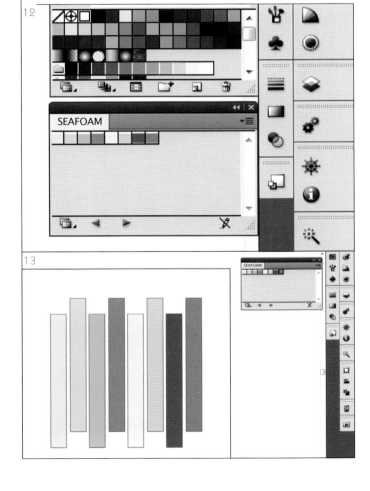

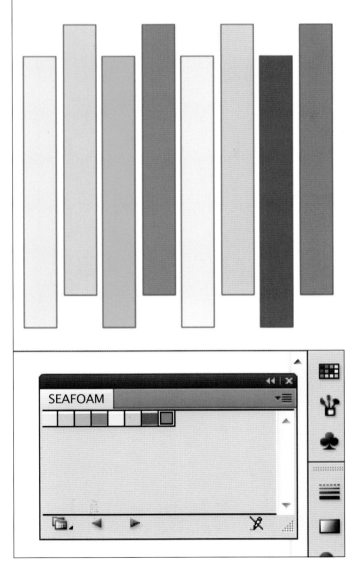

PHOTOSHOP FILTERS

Photoshop filters are used to change the appearance of a photo, a layer, or a specific selection. They allow you to apply special effects to your image, and there are a substantial number of filters available in Photoshop. In this tutorial we'll explore some of the most commonly used filters, but don't limit your use to this short list. Take the time to explore the others available and you may end up finding a new unique approach to using photography in your textile designs.

What you will learn
- How to use filters to change the appearance of a photograph

Software used
- Adobe Photoshop

Tip

When you're selecting which photo to use, make sure it is saved in an RGB color mode, as some filters may not work on CMYK images. To check the color mode of a file, open it in Photoshop then select Image>Mode.

Open your image in Photoshop

1 The first thing you should do after opening your image is to create a copy of your original. This will keep your original unaltered and easy to access if you need it.

2 Click on the Layers menu, select the Background layer, and drag it to the Create a New Layer icon at the bottom of the box.

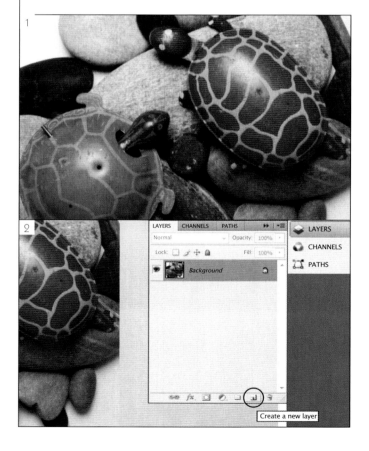

Open the Filter Gallery

3 Click on Filter and select Filter Gallery. This will open a second window where all of the filters will be listed. If your original photo is quite large, you may find that it is not completely visible in the Filter Gallery menu.

4 To resize your image so it's completely visible when you are trying out the different filters, use the pop-up menu in the bottom left corner (by the 100%) to select Fit in View.

5 Using the right arrows next to each folder, you can expand the folder to view the lists of available filters. Several of these filters are detailed in the next steps. But don't limit your exploration to those outlined below. Try the others out and see which are the most interesting to you. Many of them have a series of dialog boxes with slider bars that can be adjusted to amplify or minimize certain settings. Once you have achieved an effect you like, click the OK button in the Filter Gallery to save your effects.

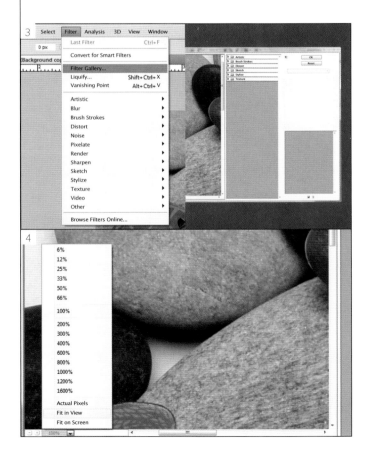

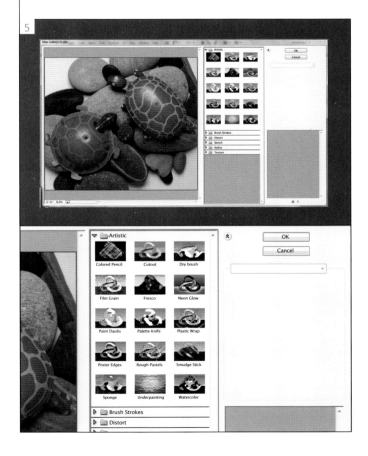

Embroidery or stained glass

6 Click on the right arrow next to Texture. Select Stained Glass. Use the slider bars to adjust Cell Size, Border Thickness, and Light Intensity.

Burlap texture

7 To simulate the look of having your image printed on heavy burlap fabric, use the Textures filter. Click on the right arrow next to Texture. Select Texturizer. Using the pull-down menu, select Burlap. Use the slider bars to adjust Scaling and Relief. You can also set your Light direction.

Neon

8 To create the feel of a neon sign, use the Glowing Edges filter. Click on the right arrow next to Stylize. Select Glowing Edges. Use the slider bars to adjust Edge Width, Edge Brightness, and Smoothness.

Abstract

9 To create an abstract design completely different from your source photo, use the Distort Filter. Filter>Distort>Wave. To try the next effect, you can step backward and "undo" what you've done using Edit>Step Backwards until the effect is cleared.

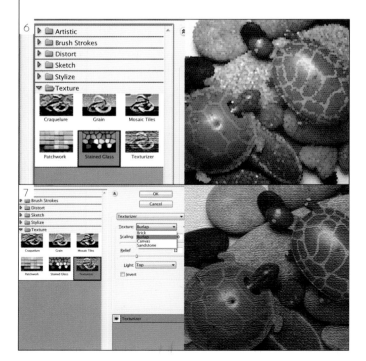

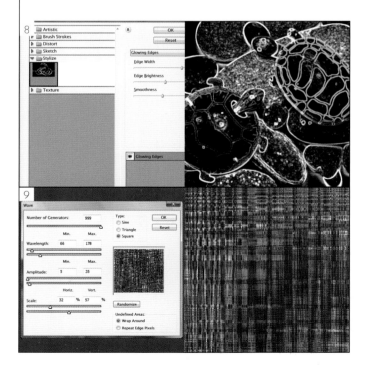

Silk screen

10 To make it appear that your image has been simplified into a silk-screened image: Layer>New Adjustment Layer>Posterize.

11 Click OK when the dialog box opens. Use the slider bar to adjust the Level.

12 To try the next effect, you can step backward and "undo" what you've done using Edit>Step Backwards until the effect is cleared.

Poster edges

13 Select Image>Mode, then select Grayscale from the menu. Flatten image and discard color information. Your image will now be rendered in grayscale.

14 To adjust the line thickness in the grayscale image, select Filter>Filter Gallery, then use the pop-up menu in the bottom left corner (by the 100%) to select Fit in View. Use the right arrow next to the Artistic folder, then select the Poster Edges filter. Use the slider bars to adjust Edge Thickness, Edge Intensity, and Posterization.

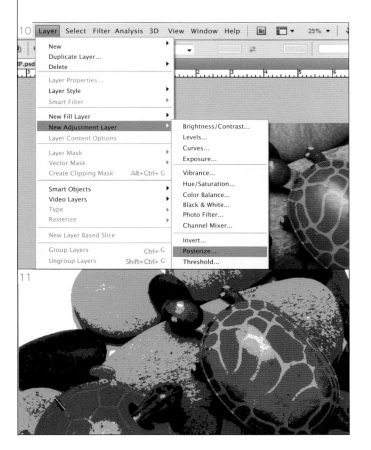

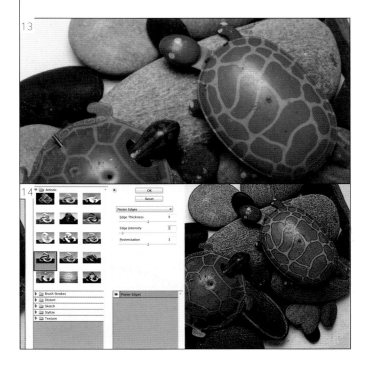

PHOTOSHOP STRAIGHT-BLOCK REPEAT

The basic repeat pattern

What you will learn
- How to create a straight-block repeat

Software used
- Adobe Photoshop

Open your design file in Photoshop

1 Start by opening up your image in Photoshop.

Create a square canvas

2 I want to square up my image so it's centered in the middle of a color block with some space around the edges. To add the additional height, select Image>Canvas Size. Use the pull-down menu to select cm and enter 1 in the height and 1 in the width. Make sure that the Relative box is checked.

3 The additional blank space has been added around the image.

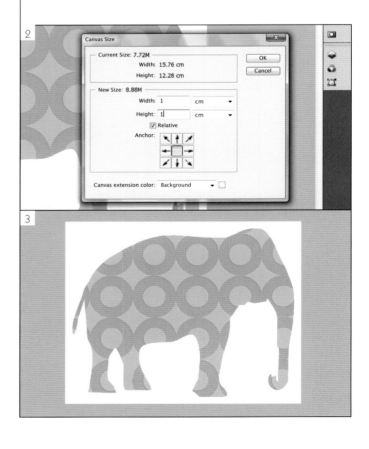

Change background color

4 I want to add a background color to my elephant, so I will use the Magic Wand Tool. If your image already has a background or if you prefer a white background, skip to step 10.

5 Using the Magic Wand Tool, select the first white area. Hold down the Shift key to select multiple areas. Once selected, they will be surrounded by a dashed white line.

6 Single click on the Foreground color.

7 Use the Color Picker to select your new color and click OK.

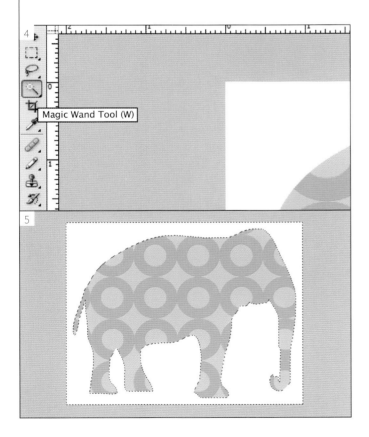

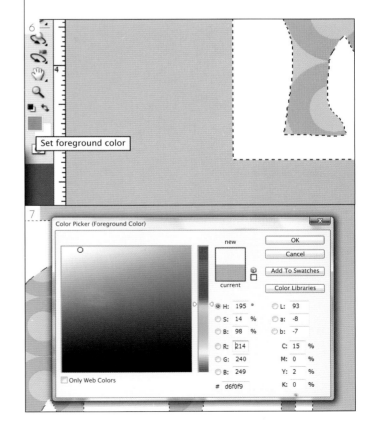

8 Now select the Paint Bucket Tool.

9 Using the Paint Bucket Tool, click in the areas you highlighted using the Magic Wand Tool. Those areas will now be filled with the color you selected using the Color Picker. Now that you've changed the background color, you are ready to create your pattern.

Define your pattern

10 Select>All. Edit>Define Pattern. Enter a name for your pattern and click OK.

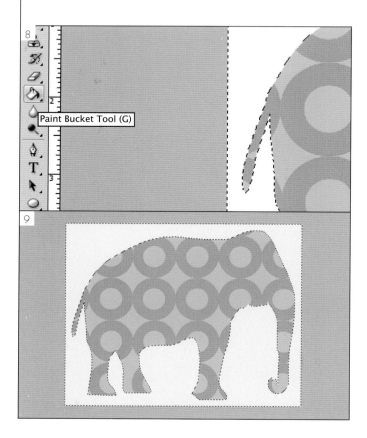

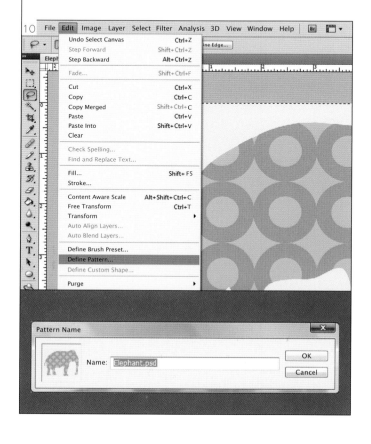

Use your pattern as a fill

11 To check your repeat and see how it tiles, we'll create a new document. File>New. Set your height, width, and resolution, and click OK.

12 Now we'll fill the new document. Edit>Fill. Select your pattern from the Custom Patterns list.

13 Next you will see the Pattern Fill box and your box will be filled with your new pattern. To change the scale of the pattern, use the slider bar.

14 For more information on preparing your files for production, see Chapter 6.

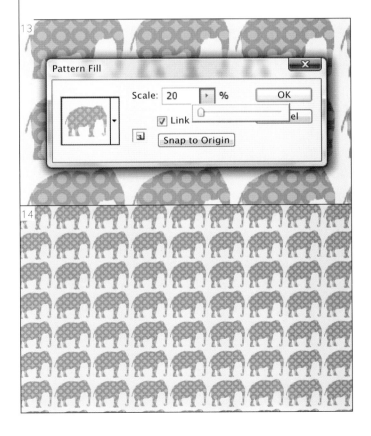

PHOTOSHOP HALF-DROP REPEAT

The half-drop repeat pattern

What you will learn
- How to create a half-drop repeat

Software used
- Adobe Photoshop

Open your file in Photoshop

1 Start by selecting and copying your image. Select>All. Edit>Copy.

Determine image size

2 Image>Image Size. Write down your image pixel dimensions (pixel height and width). Close the dialog box.

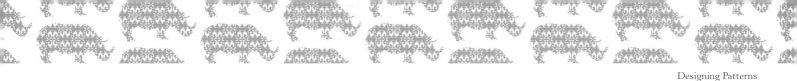

Set the offset

3 This is the step where we will add the half-drop offset to the repeat. Filter>Other>Offset.

4 Since we're setting up a half-drop repeat where images will be moved halfway down vertically, we are only going to adjust the vertical offset. Horizontal = 0. Vertical = Take your pixel height from step 2 and divide it by 2. My pixel height was 366 and 366÷2 = 183. Make sure Wrap Around is selected. Click OK.

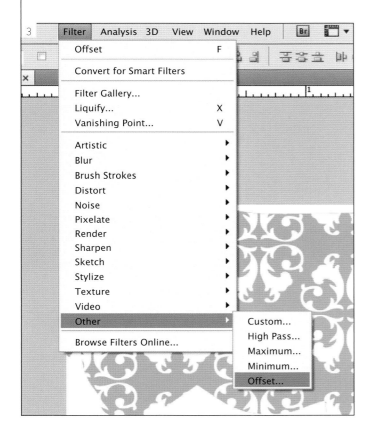

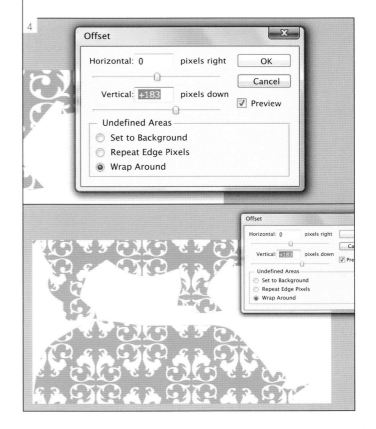

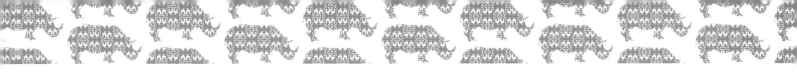

Adjust canvas size

5 Image>Canvas Size. We need to change the canvas size to allow room to add the repeat.

6 Anchor: Select the middle left box. Use the pull-down menus to select percent. Width: Enter 100. Height: Enter 0. Make sure the Relative box is checked. Click OK.

Paste in your original image

7 Edit>Paste. Then select the Move Tool and position your original image next to the offset images.

8 Next you'll flatten your layers. Layer>Flatten Image.

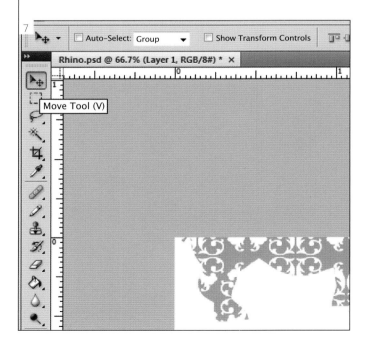

Define your pattern

9 Select>All. Edit>Define Pattern.

10 Enter a name for your pattern and click OK.

Use your pattern as a fill

11 To check your repeat and see how it tiles, we'll create a new document. File>New. Set a height and width and click OK.

12 Now we'll fill the new document. Edit>Fill. Select your pattern from the list.

13 Next you will see the Pattern Fill box and your box will be filled with your new pattern. To change the scale of the pattern, use the % pull-down menu and slider bar.

14 For more information on preparing your file for production, see Chapter 6.

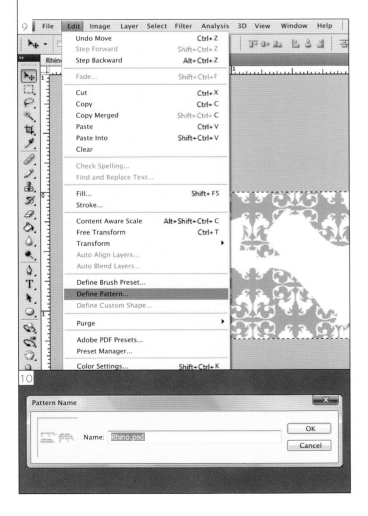

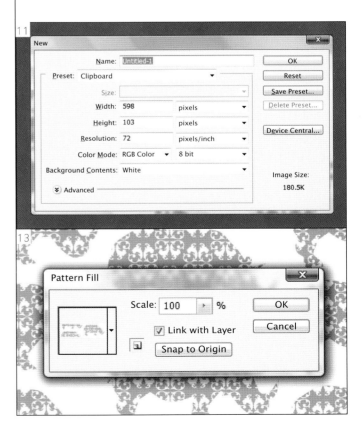

PHOTOSHOP BRICK REPEAT

The brick repeat pattern

What you will learn
- How to create a brick repeat

Software used
- Adobe Photoshop

Open your file in Photoshop

1 Start by selecting and copying your image. Select > All. Edit > Copy.

Determine image size

2 Image > Image Size. Write down your image pixel dimensions (pixel height and width). Close the dialog box.

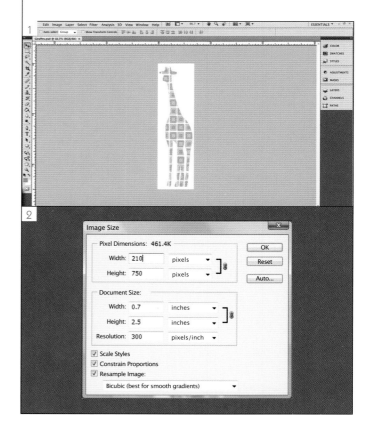

Set the offset

3 This is the step where we will add the brick offset to the repeat. Filter>Other>Offset.

4 Since we're setting up a brick repeat where images will be moved halfway horizontally to the next image, we are only going to adjust the horizontal offset. Horizontal = Take your pixel width from step 2 and divide it by 2. My pixel height was 210 and 210÷2 = 105. Vertical = 0. Make sure Wrap Around is selected. Click OK.

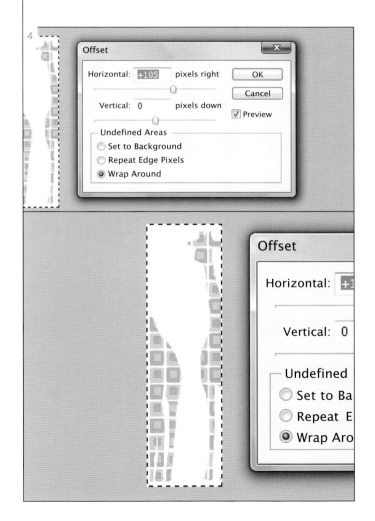

Adjust canvas size

5 Image>Canvas Size. We need to change the canvas size to allow for room to add the repeat.

6 Anchor: Select the top middle box. Use the pull-down menus to select percent. Width: Enter 0. Height: Enter 100. Make sure the Relative box is checked. Click OK.

Paste in your original image

7 Edit>Paste. Select the Move Tool and position your original image next to the offset images.

8 Next you'll flatten your layers. Layer>Flatten Image.

Define your pattern

9 Select>All. Edit>Define Pattern.

10 Enter a name for your pattern and click OK.

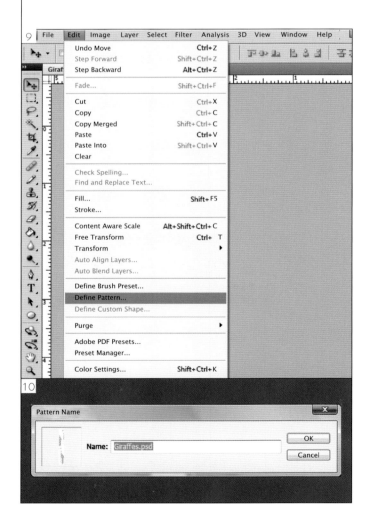

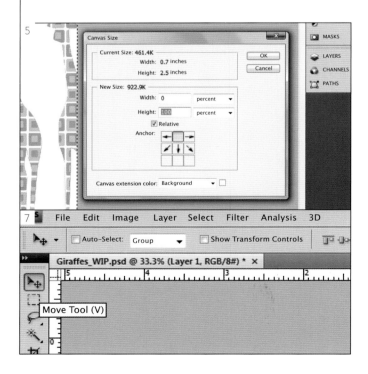

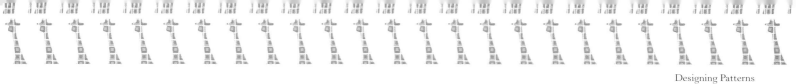

Use your pattern as a fill

11 So you can check your repeat and see how it tiles, we'll create a new document. File>New. Set a height and width and click OK.

12 Now we'll fill the new document. Edit>Fill. Select your pattern from the list.

13 Next you will see the Pattern Fill box and your box will be filled with your new pattern. To change the scale of the pattern, use the % pull-down menu and slider bar.

14 For more information on preparing your files for production, see Chapter 6.

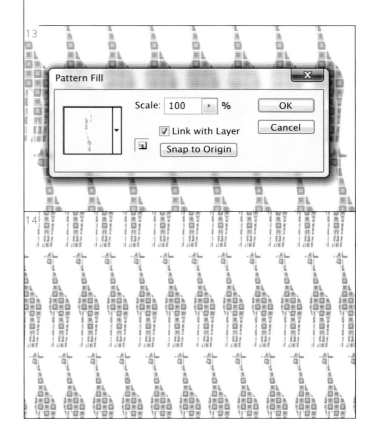

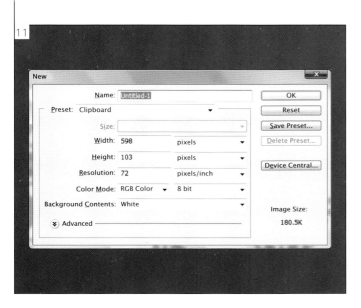

ILLUSTRATOR STRAIGHT-BLOCK REPEAT

The basic repeat pattern

Open your file in Illustrator

1 Start by opening your design file.

Group your objects

2 Group all the elements of your design together. Select>All. Object>Group.

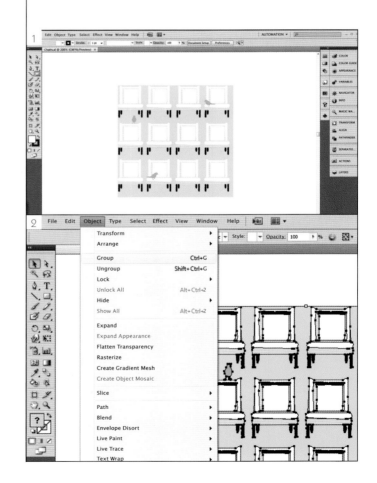

What you will learn
- How to create a straight-block repeat

Software used
- Adobe Illustrator

Define your pattern

3 Edit>Define Pattern. Enter a name for your pattern and click OK.

Use your pattern as a fill

4 So you can check your repeat and see how it tiles, use the Zoom Tool to zoom out so you have more canvas to work with. Open your Swatches menu and select the new pattern you created.

5 Select the Rectangle Tool and create a new box. It will automatically be filled with your new pattern.

6 For more information on preparing your files for production, see Chapter 6.

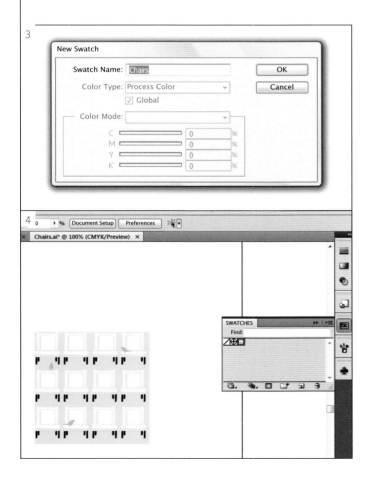

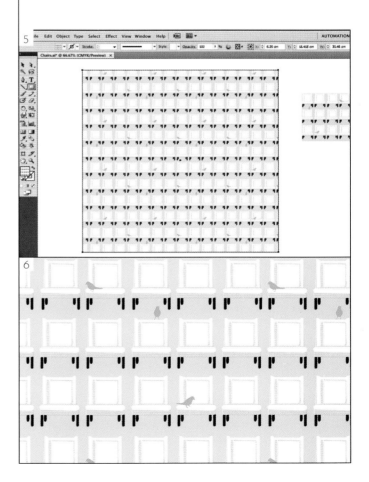

ILLUSTRATOR HALF-DROP REPEAT

The half-drop repeat pattern

What you will learn
- How to create a half-drop repeat

Software used
- Adobe Illustrator

Open your file in Illustrator

1 This image is surrounded by a square box, which makes it easier to create the repeat.

2 Next we'll turn on Show Rulers, Smart Guides, and Snap to Point. Make sure all three are selected. View>Show Rulers. Both Smart Guides and Snap to Point should have check marks next to them.

Tip 1

Click on the square box before you set each guide and they'll snap into place.

Tip 2

If you drag using the corner edge of the box, the Smart Guide will snap it into place against the original art.

Set up Guides

3 To make it easier to see the guides, click on Preferences in the top menu. Alternatively, Edit > Preferences.

4 Using the pull-down menu, choose Guides & Grid. In the Guides section, choose Light Red and click OK.

5 Before you start setting your Guides, make sure your artwork is ungrouped. This will make it easier to find the middle of your artwork. Select > All. Object > Ungroup. *(See Tip 1)*

6 Using the vertical ruler, drag guides to the left and right sides of the box. Drag down from the horizontal ruler until it snaps into place at the top, bottom, and middle of the box.

Duplicate your design

7 Using the Selection Tool, select your design. Do NOT select the guides. (You may have to hold down the Shift key and unselect them. You will know they are unselected because they will be light red.) Object > Group. Edit > Copy. Edit > Paste.

8 Paste your copied art as seen in the image. *(See Tip 2)*

9 Use the Zoom Tool to check alignment and make sure there isn't an accidental gap between the boxes.

10 Repeat and paste as shown. Drag a guide from the left ruler to the far right of your artwork.

4

Canvas Size

Guides & Grid

Guides
Color: Light Red
Style: Lines

Grid
Color: Light Gray
Style: Lines
Gridline every: 2 cm
Subdivision: 2
☑ Grids in Black

OK
Cancel
Previous
Next

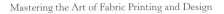

Create the repeat

11 Select>All. Object>Ungroup. Delete the two color boxes as shown.

12 Select the remaining color box and, using the handle on the right, drag the edge to the guide on the far right.

13 Open the Layers menu.

14 Using the Select Tool, select the background rectangle. Edit>Copy. Edit>Paste.

15 Drag the rectangle on top of your design and make sure it snaps into place with the guides.

16 In your Layers menu, you should see one rectangle at the very top of your layer and a second at the very bottom. If they are both at the top, select one and choose Object>Arrange> Send to Back.

Divide objects

17 Next, turn off your guides so they don't get in your way during the next step. View>Hide Guides.

18 Using your Layers menu, select the rectangle at the top of your layer.

19 Object>Path>Divide Objects Below.

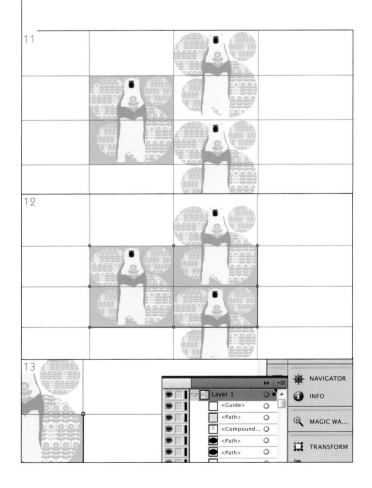

20 This step sliced apart your design so you can get rid of anything outside of the rectangle.

21 Use the Selection Tool to highlight the excess design and delete it.

22 As a final check to make sure there are no stray pieces of design that need to be deleted, using the Zoom Tool, zoom all the way in on the design and go around the edges. Delete any strays that will cause gaps in the repeat.

Create your Swatch

23 Open your Swatches menu.

24 Select>All. Object>Group.

25 Drag your design into the Swatches menu. Select the new Swatch.

26 To test your swatch and see the repeat, start by moving your design out of the way. Then, using the Zoom Tool, zoom out to view more of the page. Select the Rectangle Tool and draw a box. It will be filled with your new pattern.

27 For more information on preparing your files for production, see Chapter 6.

ILLUSTRATOR RANDOM REPEAT

This tutorial will teach you how to create a seamless, repeating pattern where the edges of the repeat are random and not easily recognizable. The key to success with this type of repeat is making sure that all of the edges match up exactly. We'll be relying heavily on grids, rulers, and guides to make sure everything is exact.

For each element that crosses over a seam line (the edges of your background box), there must be a matching element on the opposite seam. These matching elements are called pairs.

Pairs

What you will learn
- How to create a random repeat

Software used
- Adobe Illustrator

Open your file in Illustrator

1 Start by opening your artwork in Illustrator.

Create a background square

2 Using the Rectangle Tool, create a white background square. Set the background color to white and the stroke color to black (so we can more easily see the bordering edges of our square). Set your Height and Width to 4¾ × 4¾ in/12 × 12 cm (or whatever square size you are comfortable with).

Send the box to the back

3 Select your square using the Selection Tool. Send the square to the back so your artwork is on top of the white background square. Object>Arrange>Send to Back.

Turn on Guides & Grid, Rulers, and snapping

4 If they're not already active, turn on the Guides & Grid. View>Smart Guides. View>Show Grid. View>Snap to Grid. View>Snap to Point.

5 Turn on rulers. View>Show Rulers. Using the corner of the square, drag the square to the grid so it snaps into place.

Set Guides

6 To make it easier to see the guides, click on Preferences in the top menu.

7 Using the pull-down menu, choose Guides & Grid. In the Guides section, choose Light Red and set Gridline after every 1 cm.

8 Using the ruler on the left, drag guides to the left and right sides of the box. Drag down from the top ruler until it snaps into place at the top of the white background square. Repeat for the bottom of the square. *(See Tip 1)*

Tip 1

If you click on the white background square before you set each guide, you'll see the guides snap into place.

Tip 2

You may want to turn off Snap to Grid (View>uncheck the box next to Snap to Grid) during this step so you can work on your positioning outside the limitations of the grid.

Arrange your elements in the center

9 Start in the center of your design and work your way toward the edges of your white background square. To fill in the center of my design, I am using the same two elements over and over but resizing them. Edit>Copy. Edit>Paste. *(See Tip 2)*

10 It is important that you do not let your elements cross over the seams of the square yet. We'll start to build those "pairs" in the next step.

Cross the bottom seam

11 If you turned off Snap to Grid in step 9, turn it back on now. View>Snap to Grid.

12 Along the bottom horizontal seam place your elements. (I've filled my "pairs" elements with black to make it easier to follow the tutorial. We'll change the color at the end.)

Add the matching pair across the top seam

13 Now the Guides and Snap to Grid really come in handy. Start by making sure your Guides are unlocked. View>Guides. There should be no checkbox by Lock Guides.

14 Now we'll start adding the matching pairs across the top horizontal seam. Each matching pair has to be perfectly placed along the top seam or, when your repeat is finished, you will have gaps (which may make you want to pull your hair out). So follow along carefully.

15 Select the Selection Tool. Select each of your objects and the bottom horizontal guide. You can select multiple objects by holding down the Shift key as you select the objects.

16 Copy and paste the elements and the guide. Edit>Copy. Edit>Paste in Front. All the elements are still selected, so when you grab the guide, they will all move together. Drag the guide to the top seam and it will snap into place.

17 Select the Selection Tool. Open the Align Objects menu. Select the matching pairs and use the Horizontal Align Left function to move the top pair in alignment with your bottom pair. Repeat for all pairs. Now all of your top and bottom horizontal pairs are lined up.

Cross the right vertical seam

18 Place your elements along the right vertical seam.

19 Select each of your objects and the right vertical guide. You can select multiple objects by holding down the Shift key as you select. Copy and paste the elements and the guide. Edit>Copy. Edit>Paste in Front.

20 All the elements are still selected, so when you grab the guide, they will all move together. Drag the guide to the left seam and it will snap into place.

21 Select the Selection Tool. Open the Align Objects menu. Select the matching pairs and use the Vertical Align Bottom function to move the top pair in alignment with your bottom pair. Repeat for all pairs. Now all of your left and right vertical pairs are lined up.

22 Next you need to change the coloring of the elements so they are no longer black. If you need to make any changes to your composition, this is the time to do so. Once you have created the repeat swatch you will only be able to change the scale of the repeat and will no longer be able to modify elements or colors.

Creating the repeat

23 Before we can create our swatch and check our repeat, first we need to clear the guides. View>Guides>Clear Guides.

24 Select the Selection Tool. Select all objects (except your white background square) and group them together. Be very careful not to nudge any of your objects while you're selecting them. Even the tiniest little movement of an object that crosses a seam will mean the pairs won't all match up. Object>Group.

25 Next we need to change the border stroke color of our white background square to white. Select the Selection Tool. Select the white background box, change the Stroke to white.

26 We need to create a copy of the white background box. Edit>Copy. Edit>Paste.

27 Now we need to get the two white squares perfectly aligned, but without moving the original background square. In your Layers menu, you should see one square at the top and a second at the bottom. If they are both at the top, select one and choose Object>Arrange>Send to Back.

28 Using your Layers menu, select the square at the top and the square at the bottom. Use the Align menu to align the new square on top of the original bottom square. Be careful not to move the bottom square.

29 Select the top white square. We need to make this square invisible by removing the white background color and the stroke color.

30 Next we need to send this invisible square to the back of the page. Object>Arrange>Send to Back.

Creating the pattern

31 If you find it distracting to have the grid on, you can turn it off now. View>Hide Grid.

32 Next we need to select both the squares and the design. Select>All. Edit>Define Pattern. Give your pattern a name.

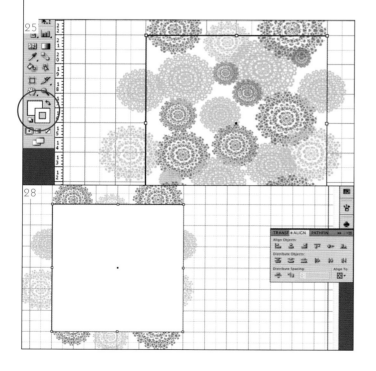

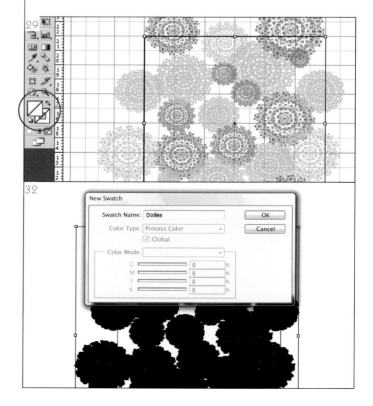

Testing the swatch

33 Move your grouped design to the side and then deselect it by clicking on the blank canvas.

34 In the Swatches menu, select the new Swatch.

35 Using the Zoom Tool, zoom out to view more of the page.

36 To test your Swatch and see the repeat, select the Rectangle Tool and draw a box. It will be filled with your new pattern.

37 If there are issues with your repeat and all of your pairs don't match up, all you need to do is ungroup all of your objects, go back to step 11, and start again with placing your elements on the seams.

Optional: Adjusting scale

38 Select the Selection Tool. Select the new box you just filled with your repeat. Object > Transform > Scale.

39 Change the percentage in Uniform Scale. Make sure only the Patterns checkbox is selected. Click OK.

40 To create a file for your printer with your seamless random repeat, create a box the same size as your original square 4¾ × 4¾ in/12 × 12 cm, set your stroke to none (invisible), and fill your box with your pattern. Next you can export your file according to your printer's requirements. For more information on preparing your file for production, see Chapter 6.

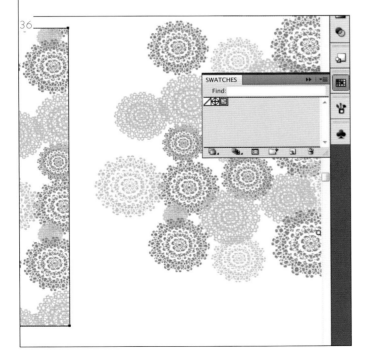

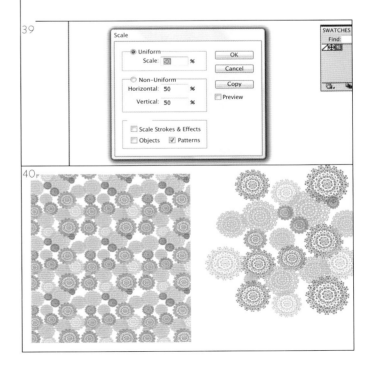

PHOTOSHOP PATTERN MAPPING

Chair template

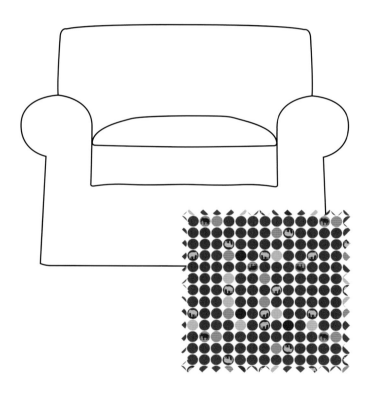

What you will learn
- How to map texture patterns into line art illustrations

Software used
- Adobe Photoshop

Open your line drawing

1 This tutorial will demonstrate how to map a Photoshop pattern into a line drawing. For this example, we'll apply patterned upholstery to a chair. Start by opening your line drawing in Photoshop. Before you start this tutorial, I suggest you read it in its entirety first so you can learn about applying pattern—with and without applying perspective to your image—before you get started.

Create a new file for your pattern

2 In order to have the most control over your scale, and the ability to free transform your patterns, create a second file for your pattern. File>New. Width: 800 pixels. Height: 800 pixels. Resolution: 150 pixels/inch. Color Mode: RGB Color, 8 bit. Click OK.

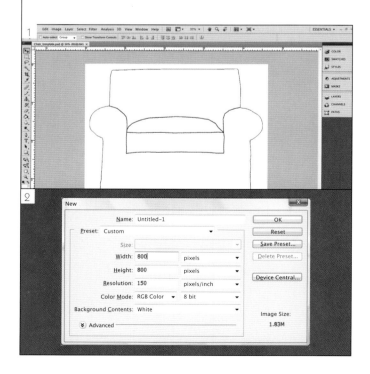

3 Select>All. Layer>New Fill Layer>Pattern.

4 When the New Layer window opens, click OK.

5 Locate the Pattern you want to use from the Pattern Library (using the down arrow). Click OK. Select>All. Edit>Copy Merged.

Apply your pattern to your line drawing

6 Go back to your line drawing. Open the Layers menu.

7 Select the Magic Wand Tool.

8 Select a portion of your drawing. It will now be surrounded by a dotted line. Now we will create the fill layer where we can apply our pattern. Layer>New Fill Layer>Pattern.

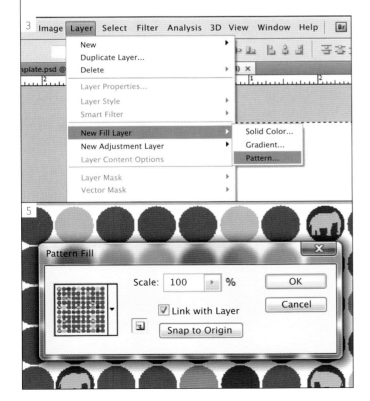

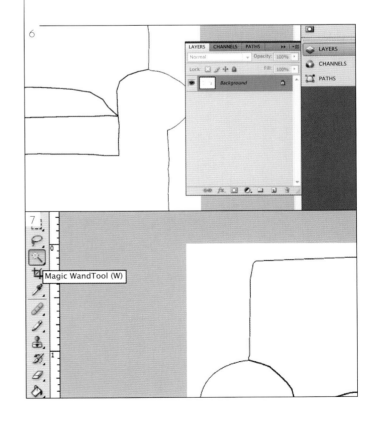

9 When the New Layer window opens, click OK.

10 Locate the Pattern you want to use from the Pattern Library (using the down arrow).

11 In the Layers menu, click on the Background layer. Repeat for all other pieces of your drawing where you don't need to apply any perspective or skewing of the pattern to make it look more realistic.

Apply perspective to your pattern

12 For areas of your drawing where you need to apply perspective or skew the pattern, we'll paste in the pattern you copied in step 2. In the Layers menu, click on the Background layer.

13 Select the Magic Wand Tool. Select a portion of your drawing. Edit>Paste Into.

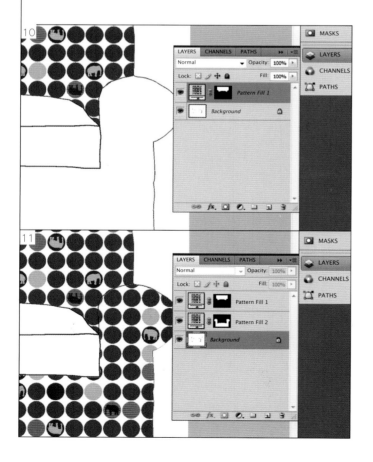

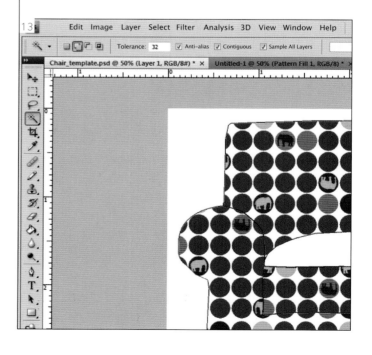

14 Edit>Free Transform. This will apply four handles to the pattern you just pasted into your selection. You can use the handles to adjust the positioning of your pattern:

- To skew your pattern to add perspective, hold down the Control key when using a handle.
- To constrain the dimensions, hold down the Shift key when using a handle.

15 Hit the Enter key when you are happy with the transformation. In the Layers menu, click on the Background layer.

16 Repeat for any remaining pieces of your drawing.

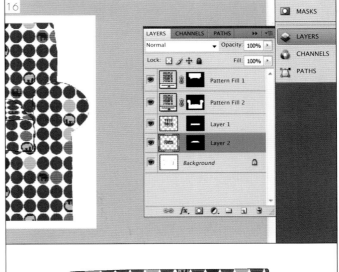

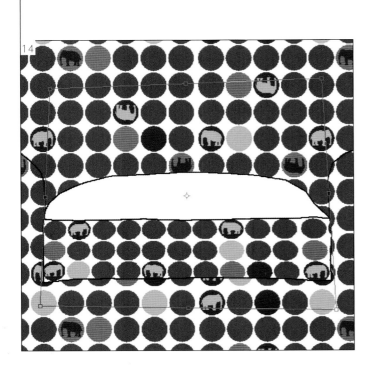

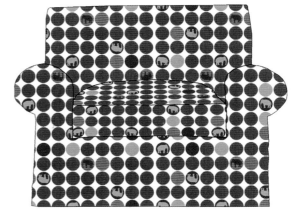

UNDERSTANDING FABRIC, INKS, AND DYES

Understanding the differences in types of textiles and the ways color is applied to them will come in handy as you experiment with different types of printing.

Hand-dyed linen by Laurie Wisbrun

TYPES OF FABRIC

One of the most exciting parts about printing your own fabric is the ability to experiment with different types of base cloths. If you're printing your fabric digitally, the types of fabric available to you will be dependent on the specific printing service you use.

But if you're printing by hand, the number of fabrics you can use is exponentially greater. Let's start with some basic fabric definitions.

There are three major categories of fabric: cellulose, protein, and synthetic. Each type of fabric will accept color differently, so before you begin any project it's key that you match the type of fabric you plan to use with the appropriate ink, paint, or dye.

Cellulose

- Cotton, linen, hemp, ramie
- Fibers in these fabrics come from plants

Proteins

- Silk, wool, cashmere
- Fibers in these fabrics come from animals

Synthetic

- Polyester, rayon, nylon, acetate
- Fibers in these fabrics are either completely made of or are regenerated from cellulose or protein fibers
- These fabrics are generally difficult to dye

1 These sample swatches were taken from a 100+ sample swatch pack from Dharma Trading Co.

Natural Organic Muslin	Cotton Interlock	Linen Rayon	Essex Linen PFD	Handwoven Natural Handspun Cottona
Silk Satin	Hemp Silk Charmuese	Bleached Linen	Raw Silk	Cotton Sateen
Bamboo Rayon Fleece	Organic Cotton Denim Twill	Cotton Silk	Rayon Satin	Combed Cotton Lawn
Heavy Crepe de Chine	Cotton Duck	Heavier Cotton Gauge	Kona Cotton PFD	Cotton Velveteen PFD

FABRIC TREATMENTS AND WEIGHTS

When you are purchasing fabric to hand-dye, paint, screenprint, or stamp, pay close attention to how a fabric is labeled and treated. The "whiteness" of the fabric will vary based on the treatment, and any treatments may reduce the ability of a dye to adhere to the fibers.

Natural

- Not bleached or optically whitened
- Known as Greige Goods (pronounced *gray*)
- Some natural fabrics are also organic

PFD

- PFD is an acronym for Prepared for Dyeing
- Washed, bleached, but not optically whitened

Bleached

- Washed, bleached, and optically whitened

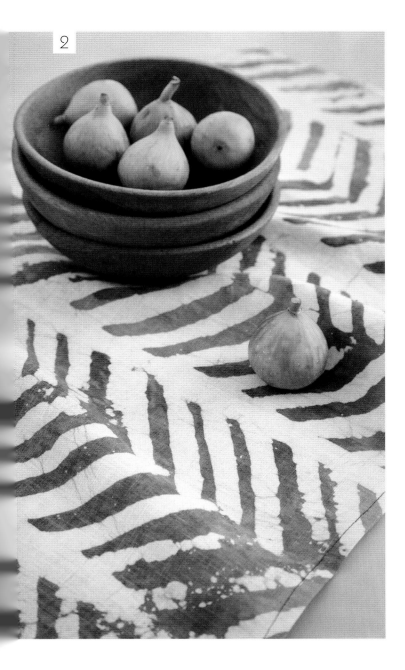

Fabric weight and weave

The weight and thread count of a fabric affects how the fabric drapes, what the hand is (how it actually feels to the touch), and its suitability for different end uses.

Weight

- The weight of a fabric is measured in ounces per square yard of cloth
- The higher the number of ounces per square yard, the heavier the fabric
- A heavier-weight fabric is usually thicker

Thread count

- The thread count of a fabric is measured in threads per 1 square inch of cloth
- A higher thread count means a tighter weave and a softer feel to the fabric

1 Twist coasters designed and screenprinted on wool by Lucie Summers

2 Linen hand-dyed batik tea towel in Chevalet/ Wisteria by Sara Hopp Harper of 5 o'clock crows

TEXTILE DYES, INKS, AND PAINTS

Dyes, inks, and paints are all used to apply color to fabric. They each work differently, which affects how you can use each one, how they will adhere, and the types of projects they are suitable for.

- A dye bonds molecularly with the fabric, changing the color of the fabric itself
- Inks and paints sit on top of the fabric as a layer
- Most inks are more liquid and more transparent than paints
- Colorfastness for inks and paints is achieved through heat setting
- Dyes rely on specific chemicals to achieve colorfastness

Before you purchase any dye, ink, or paint, it's important to decide which technique you'll be using and what type of fabric you'll be working with. Dharma Trading Co. (www.dharmatrading.com) provides a variety of online tools and content to help you identify which product is the right one for your project.

Textile paints and inks
- Come in a variety of consistencies tailored to specific applications
- Can be thinned with water to control consistency
- Inks are often thinner than paints

1

Block printing inks

- Specially formulated to adhere to carved printing blocks (often hand carved from rubber)
- Thicker than other inks
- Sometimes labeled as block printing paints

Screenprinting inks

- Specially formulated to be able to be applied through the mesh of a screen with a squeegee
- Available as water- or oil-based formulas

Fabric dyes

- Dye particles actually bond with the fabric's fiber on a molecular level and change the color of the fabric itself

1 Assorted textile dyes, inks, and paints

2 Layers paint effect, hand-painted fabric by Deborah O'Hare

VAT-DYEING FABRIC

by Malka Dubrawsky

Folks sometimes ask me whether I can tell the difference between a commercially produced solid-colored fabric and a hand-dyed one. My unequivocal response is yes. There's a depth of color and sheen to a hand-dyed cotton or linen that is just not present in a commercially colored fabric. That richness of a hand-dyed color is the product of hours spent soaking in a dye vat.

Another oft-asked question is whether vat dyeing can be done in a home setting on small quantities of fabric. Again I say yes. All of the supplies are easily obtained from online vendors and some are common household items available at the grocery store. The dye process detailed here is geared toward dyeing a yard or two of fabric and does not require dedicated studio space.

Safety

The only caveat I would add has to do with working safely. Although you can set up and dismantle your dye "space" as needed, it's important to remember that all pans and measuring tools used for dyeing need to be exclusive to this process. Also, it's important to wear gloves and a respirator or dust mask when handling powdered dyes.

Materials

Before you begin you'll need to gather the necessary supplies. The only item you will absolutely need to order from a dye supplier is the dye. In this process we'll use a cold-water dye called Procion MX. This will allow us to make dye baths without needing a heat source. It also comes in a wide array of colors and can be purchased in small quantities. Many dye suppliers put together "starter kits" that allow you to try a few colors, so you can sample several dyes without spending a lot of money.

Other than the dyes, you'll probably also want to order your fabric from the dye supplier. Though these dyes will color all cellulose fibers and can be used on linen, cotton, and rayon, I prefer to buy a high-thread-count pima cotton for the majority of my dyeing. The high thread count means there are more places for dye to be deposited, and that creates a deeper, more richly colored cloth.

The only potentially unfamiliar chemical needed is soda ash. Soda ash, or sodium carbonate, is probably better known as a swimming pool chemical than a dye fixative. Although dye suppliers sell soda ash, I find it is cheaper and more convenient to buy it at my local swimming-pool supply store. Another item that can be purchased through a dye supplier, but is just as easy to find at a local hardware store, is a respirator or dust mask.

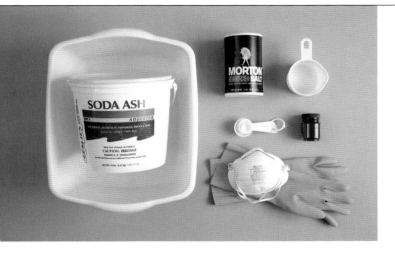

The remaining supplies are available at the grocery store. You'll need a calibrated pitcher or bucket, a dishpan, table salt, a measuring tablespoon and measuring cup, dishwashing gloves, an apron, and water softener if your area has hard water. Additionally, you'll need a pair of plastic containers or tubs for measuring chemicals.

Dye recipe

The dye recipe I'm detailing here is ideally suited to dyeing a half yard to a yard of fabric. If you'd like to dye longer lengths you'll need to increase all the amounts proportionately and may need to get a larger container to hold your dye bath. No matter how much fabric you're dyeing, it's a good idea to wash the fabric in standard laundry detergent before you dye it. Drying it is optional, but washing helps to remove any sizing or residual grease that may be present and can affect how the dye bonds with your fabric.

Begin by measuring a gallon of room-temperature water into the calibrated pitcher or bucket. Pour the water into the dishpan and add one cup of salt and one tablespoon of water softener if needed. Fill one of the plastic containers with one cup of hot water. Put on your apron, gloves, and respirator/dust mask, and measure 1 tablespoon of dye powder into the container. Stir until dissolved. Once the dye is dissolved you can remove the

respirator/dust mask, but keep your gloves and apron on to protect your skin and clothing. Add the dissolved dye to the dishpan. Place the fabric in the dishpan and swirl it around to ensure that the fabric is coated with dye. Let the fabric sit for 30 minutes to an hour. Measure 1 cup of hot water into the second container and add 4 heaped tablespoons of soda ash. Dissolve the soda ash and pour the mixture into the dishpan with the fabric. Once you add the soda ash, the chemical process that binds the dye to the fiber begins. Let the dye bath sit for at least 4 hours to overnight, stirring occasionally. Unlike other dye processes, the dye bath will not look different when spent.

At this point remove the fabric and dump the liquid down the drain. In liquid form, dye is nontoxic and can be disposed of in a sink. Rather than rinsing the fabric in the sink, I prefer to wash it in the washing machine. This rinses the fabric thoroughly, and I can move on to doing something else, like planning my next dye bath.

RESIST DYEING USING CLAMPS | ITAJIME SHIBORI *by Malka Dubrawsky*

The concept behind *itajime shibori* is simple: Fabric is sandwiched and bound between two similar shapes then immersed in a dye bath. The shapes function as a resist and prevent dye from seeping into the areas covered by the shapes. When unbound, the fabric reveals the pattern created by the shapes.

Traditionally, itajime involved wooden blocks as resists and twine for binding the shapes to the fabric. I've updated that process a bit by using plexiglass shapes and metal C-clamps. The transparency of the plexiglass allows for exact placement of the shapes and C-clamps, ensuring a tight seal resist, creating a crisp pattern.

For clarity's sake, this tutorial refers to 4-in/10-cm plexiglass circles as the shapes used in itajime, but itajime shapes are available in multiple sizes and shapes. Additionally, if you have access to a Skilsaw with a plastic blade, you could cut any shape you desire.

Supplies

- Fat quarter of cotton or linen fabric measuring about 18 × 22 in/46 × 55 cm, prewashed to remove sizing
- Standard size dishpan or bucket
- Measuring spoons
- Measuring cup
- Plastic or ceramic bowls for measuring chemicals
- Procion MX dyes
- Soda ash
- Salt
- Two 4-in/10-cm plexiglass circles
- 4 C-clamps
- Dust mask
- Rubber gloves
- Stirring spoon

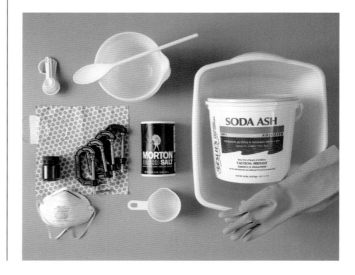

Setting up your clamped sandwich

1 Fold fabric in half.

2 Repeat step 1 so that the fabric is folded into fourths.

3 Center shapes along the bottom and top of the folded fabric, making sure to align both shapes.

4 Beginning with one clamp, secure the clamp to the fabric sandwich and tighten.

5 Repeat step 4 to attach all four clamps to the fabric sandwich, making sure to evenly space the clamps. Wet the clamped fabric and tighten all four clamps again to ensure a good seal. Set aside. Fill in the space but stay away from the top and bottom edges.

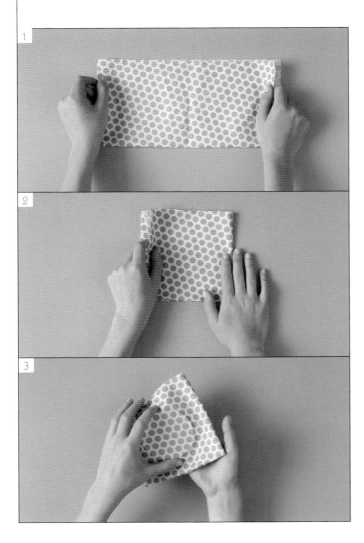

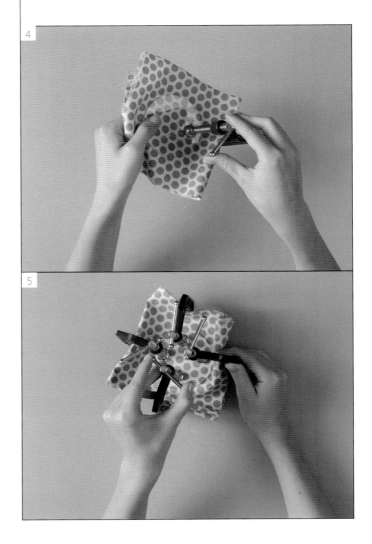

Making the dye bath

6 Measure and pour 1 gallon (3.79 l) of warm water into the dishpan. Add one cup of salt to the dishpan and stir to dissolve.

7 Measure and pour one cup of hot water into a separate plastic bowl. Put your gloves and dust mask on. Measure and pour 1 generous tablespoon of dye powder into a plastic bowl of hot water. Stir to dissolve.

8 Add the dissolved dye to the dishpan. You can remove your mask now. Place the clamped fabric sandwich into the dishpan. Swirl the sandwich slightly to distribute the dye. Wait a few moments to let the dye seep into the fabric.

9 Measure and pour one cup of hot water into a second plastic bowl. Add 4 generous tablespoons of soda ash. Stir to dissolve. Add the dissolved soda ash to the dye bath.

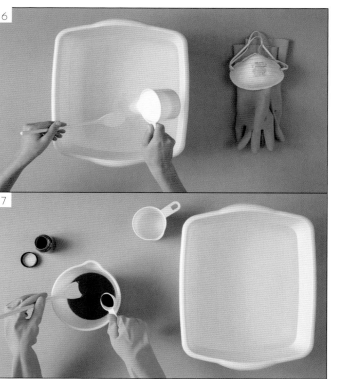

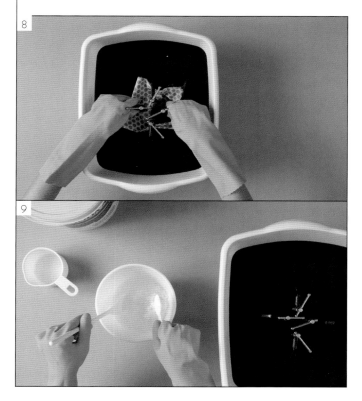

10 Swirl the clamped fabric sandwich to encourage even distribution of dye and chemicals. Allow the clamped fabric sandwich to sit in the dye bath for at least 6 hours to overnight.

11 With your gloves on, remove the fabric sandwich from the dye bath and rinse in the sink. Dump the dye water down the drain. Wash the dyed fabric in your washing machine on a cold setting using standard laundry detergent.

Note

This amount of water and dye will dye more than one clamped fabric sandwich. Based on the shape of your bucket or dishpan, you should be able to dye several fabric sandwiches simultaneously.

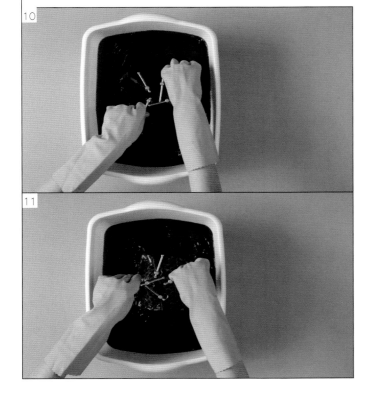

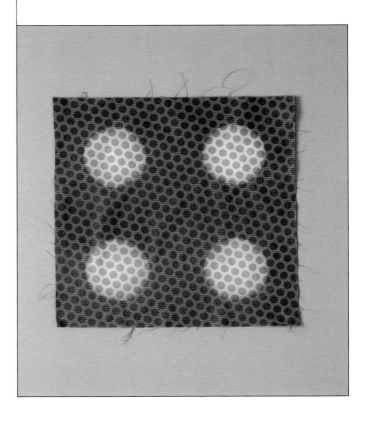

RESIST DYEING USING POLE-WRAPPING | ARASHI SHIBORI

by Malka Dubrawsky

The word *arashi* means *storm* in Japanese—a fitting name when you consider the strong, angular lines this particular resist method creates on fabric.

Arashi is a subset of *shibori*, a variety of fabric resist methods that create patterning through binding, stitching, compressing, folding, and twisting. Arashi is also referred to as pole-wrapping because the fabric is bound to a pole with thread. Traditionally, the fabric is bound to the pole on the diagonal, secured with thread, and compressed to create the distinctive patterning.

Materials

Many of the materials required for arashi are the same as those needed for vat dyeing. Procion MX dyes are still my coloring method of choice because they're ideal for cotton and do not need heating. Additionally, the auxiliary chemicals continue to be soda ash, salt, and water softener, as needed, and all the measuring tools and safety equipment used in vat dyeing are needed for arashi. The most glaring difference is that arashi poles are dyed in buckets instead of dishpans and that the fabric is compressed on the pole before dyeing.

The pole is actually a bit of PVC piping available at any hardware store. PVC piping comes in varying thicknesses and diameters. My preference is a very thin piping of no more than ¼ in/6 mm and a diameter of between 2 in/5 cm to 4 in/10 cm. Since PVC piping is inexpensive, I like to have a variety of widths available. Piping does come in long lengths, but all you need is about 18 in/46 cm. Most hardware stores will happily cut any length requested.

1 Supplies for arashi

2 PVC piping for pole-wrapping

3 Taping fabric to the pole

4 Depending on how the pole is wrapped, the resulting fabric can take on a completely different feel. Fabric on left: Traditional wrap (demonstrated above). Fabric on right: Ruching wrap method

Another key ingredient in the process is upholstery thread. This extremely strong thread is ideal for binding the fabric to the pole by winding the thread around the pole. Finally, strapping tape is needed to secure the fabric and thread to the pole before the winding begins and after the fabric is wound and compressed on the pole.

Since I primarily work with 4 in/10 cm wide poles, I prefer to limit my fabric size to about ½ yd/46 cm. This size is manageable to work with, doesn't take too long to wind and compress, yet still yields a substantial length of finished fabric. Begin attaching the fabric to the pole by taping one corner to the pole close to one end. Tape the end of the upholstery thread to the pole close to the taped corner. Begin winding the thread around the pole, spacing the lines about ¼ in/6 mm apart and making sure to keep the thread taut as you work. Wrap about 4 in/10 cm, adjusting the fabric as you wrap so that it lies flat on the pole.

While holding the thread taut in one hand, compress the wrapped fabric toward the pole end. Continue wrapping the thread, pausing about every 4 in/10 cm to compress the fabric. When the fabric is completely wrapped and compressed, cut the thread from the spool and tape it to the pole.

Once the fabric is wrapped, make the dye bucket as you would for vat dyeing, making sure the water level covers the fabric. When the dye bath is spent, unwrap the pole by removing the tape and thread. Wash the fabric in the washing machine to thoroughly remove any excess dye.

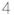

INTERVIEW
Malka Dubrawsky

Malka Dubrawsky is a textile artist based in Austin, Texas. She designs, patterns, and dyes fabric, which she sells in her online store, A Stitch in Dye. An expert in hand-dyeing who has a uniquely modern style, Malka has authored two books of her own: *Color Your Cloth: A Quilter's Guide to Dyeing and Patterning Fabric* and *Fresh Quilting: Fearless Color, Design, and Inspiration*. She also designs and writes patterns and teaches workshops and classes on dyeing. An accomplished crafter, Malka creates quilts, pillows, and other sundries out of her hand-dyed and patterned fabric.
www.stitchindye.etsy.com

Q: How did you get started with dyeing fabric?

A: I started sewing right after I graduated from art school. I have a BFA in printmaking, but I didn't really have a studio that was appropriate for the type of printmaking I focused on in college. I'd always been interested in sewing and decided to translate some of my drawn images into fiber. Not too long after that, I realized that I wanted to control the colors and patterning of the fabrics that went into my fiber pieces. I learned how to dye and pattern fabric, first using wax resist and then various shibori techniques.

Q: What is your favorite part of the process?

A: When I'm using wax resist to pattern fabric and I'm repeating a specific design, I enjoy the meditative quality that this kind of repetitive work brings. I also love the surprise of pulling a piece of fabric out of the dye bath and discovering what it looks like. Dyeing is not an exact process, and you have to learn to work with, and celebrate, the fact that every piece is unique. Strangely enough, I also love ironing the fabrics once they're done being processed and washed. It's then that I get to truly enjoy the colors and pattern for the first time.

Q: What do you find the most challenging about dyeing fabric?

A: I find consistency to be the most challenging aspect of dyeing fabric. A part of my brain, probably the part that seeks out neatness and order, would like to be able to reproduce patterns and colors exactly. Unfortunately, that's not always possible. It's interesting that the very same thing that's challenging about this process is also one of its charms.

1

2

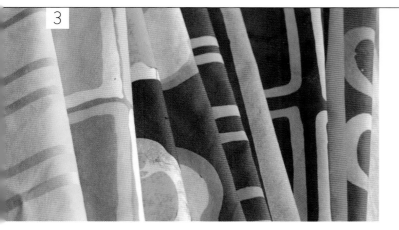

5

Q: What do you do when you are suffering from lack of inspiration?

A: I make it a point to always leave some mundane task undone in my studio. I find that if I know that I have to iron fabric or thread a bobbin, or mix a dye bath, then that helps me ease into another workday. I don't believe in waiting for inspiration. I find that just working naturally starts my mind thinking about new possibilities or assignments. Not everything I think or dream up is worth exploring, but that's all part of the process.

recall her name, but her words were so powerful and true. She said, "There are a lot worse things in life than ruining a piece of fabric." Whenever I feel tentative about trying something new, I think about that. It's just fabric.

Q: What advice would you offer someone who wanted to explore dyeing?

A: I would encourage them to be fearless. One of the best quotes I ever read about working with fabric came from a quilt artist who had been recently diagnosed with cancer. Sadly, I can't

Q: Can you share your shortlist of resources for materials?

A: Dharma Trading Co. (www.dharmatrading.com) and Pro Chemical Dye (www.prochemicalanddye.com). R0ssie (www.r0ssie.etsy.com) is a great resource for the plexiglass shapes needed for itajime.

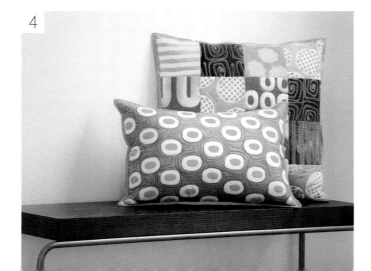

4

1 Big Circles fabric

2 Quilt detail

3 Assorted fabrics

4 Assorted pillows featuring Malka's hand-dyed and patterned fabrics

5 Detail of Rounded Patches pillow

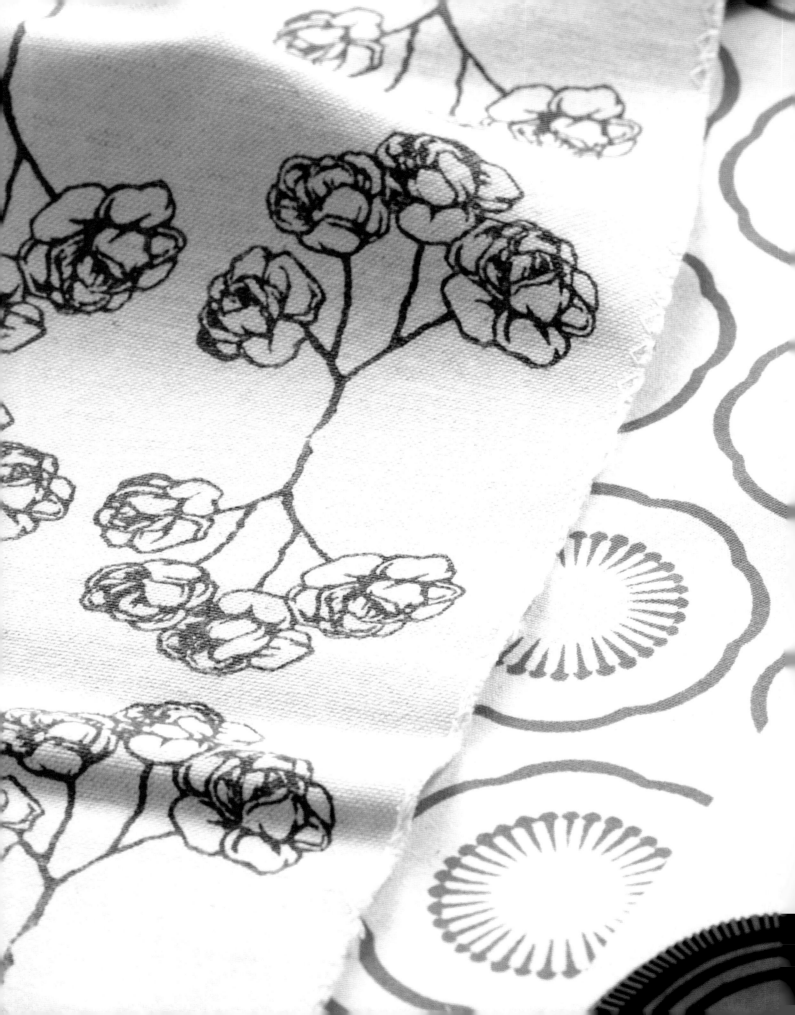

CHAPTER 5
HAND PRINTING

In this chapter, we'll explore several approaches to hand printing textiles, and I hope you'll experiment with each technique yourself. When designing fabric, it's important to understand the different printing techniques, so I encourage you to experiment with different methods.

Assorted hand-printed fabrics by Jesse Breytenbach

INTRODUCTION TO HAND PRINTING

Written in collaboration with Jesse Breytenbach, Jezze Prints

Whether you're using brushes, stencils, stamps, paints, dyes, or inks, there's a world of possibility for creating patterns and prints on fabric. With each printing method, pattern and color are applied to fabric in a different way and result in a different look. Because these fabrics are created by hand, revel in their handmade nature. The "oops" spots on your printed or dyed fabric may turn out to be the most unique and special areas of your creations. The key to hand printing is experimentation and not being afraid of "messing up."

In this chapter we'll cover a few different approaches to hand printing. If you're interested in learning more and trying out additional techniques, I highly encourage you to continue your exploration into hand printing. In the Resources chapter you'll find a list of some wonderful books that delve more deeply into each approach. And if you have the opportunity to take any courses in hand printing, they are a wonderful way to quickly immerse yourself in a new technique.

Printing setup

Before you begin printing, remember the fabric should be prewashed to remove any starch. If the printing surface isn't washable, cover it with newspaper or a plastic tablecloth before putting the ironed fabric on it. Check that there are no loose threads under the fabric. Wear an apron when printing; you'll need to wipe ink off your fingers often.

Cleaning up

Although water-based ink isn't solvent-heavy like oil-based ink, it still contains pigments and binders, and you want to flush as little of these as possible into the water supply. Wipe all implements with paper, toilet paper, or newspaper before washing. Wipe the glass rolling surface clean while the ink is wet, rather than rinsing the ink off,

1 Cotton tea towel by Sahara Dalley. Hand-dyed then block printed by hand using 13 different printing blocks made from wood and copper

2 Pillow cover sewn using Twist and Weave fabrics designed and screenprinted on linen/cotton by Lucie Summers

3 Yardwork's Garden Party clear décor stamp

or let it dry completely and scrape the dry ink off. Remove as much ink as possible from the sponge roller by rolling it repeatedly over sheets of newspaper, and finish by washing it clean in water.

Wipe as much ink as possible off the printing blocks, and then rinse with water, scrubbing gently with an old toothbrush. Pat dry and leave to dry completely, standing on end. Do not let ink dry on the block, as it can be hard to remove.

Washing, curing, and setting

Most textile inks and paints need heat curing to be permanent. Always check the ink manufacturer's instructions for curing. If it's not on the bottle, you should be able to download technical information about the ink from the manufacturer's website.

Water-based inks cure by evaporation of the water in the ink. Thicker fabrics take longer to cure, as the fibers can hold water. A humid atmosphere can also affect how well the fabric cures.

In general, ironing with a hot iron (cotton setting) is the simplest way to cure prints. Leave the print to air-dry, and once it is thoroughly dry, iron the fabric on the back of the print. Take your time; stop just shy of scorching the fabric, but do let it get very hot. If this sounds tricky, experiment with some test prints to get a feel for it.

Prints can also be cured in the oven; again, check the manufacturer's instructions to find out at what temperature the ink will cure. Set the oven to this temperature, and once it's warmed up, turn it off. Place the fabric on a baking tray in the oven. Leave it for 15–20 minutes. Large pieces may need to be cured a few times, rearranging the folds each time to ensure that all parts of the fabric get hot enough. Don't try to cure too many pieces of fabric at once; the water needs to evaporate off the ink surface. When you take the still-warm fabric out of the oven, unfold it to let the steam evaporate.

To test whether the ink has cured, soak a piece of the print (or a test print) in water. If the ink hasn't cured properly, it will feel slimy when rubbed.

GENERAL BLOCK PRINTING TIPS

by Jesse Breytenbach

Single color prints

It's helpful to design for the printing medium, rather than trying to fight its limitations. It takes practice to know what will print well, but generally large, flat areas of color are better suited to an approach like silk-screening, rather than block printing. Small areas or lines are better for block printing. Pressing a small area exerts more pressure than pressing a large area, and so more ink is laid down. Break up large, flat areas by cutting texture or patterns into them—even light cross-hatching will make a difference.

Avoid widely spaced design elements; this kind of block is frustrating to ink, as the blank areas can pick up ink and print.

On the other hand, particularly if printing textured fabric, the inconsistency of color can be part of the appeal of block printing, making it seem less mechanical than the flat, sometimes harsh, texture of screenprinting.

1

1 Different textured fabrics can add dimension to block printing

2 The same ink was used to print these fabric swatches to demonstrate ink transparency

3 When overlapped, inks can combine to provide new hues

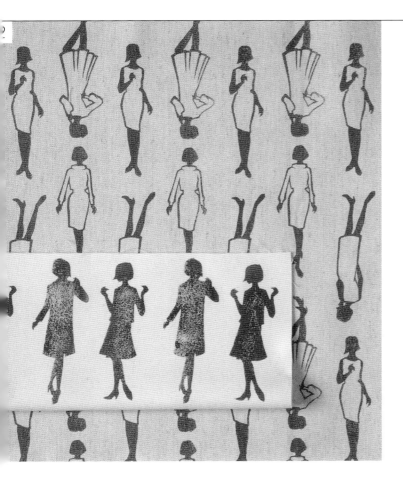

Print two or three colors over each other, letting the inks overlap to create tones. Or mix printing methods—block printing over silk-screen or stencil—to create designs that vary in color intensity. Stenciling with a transparent stencil over block prints is an easy way to add accurately placed details.

Most standard fabric inks/paints are slightly transparent, so they will only print their true color on white fabric. The color of the fabric influences the color of the print, particularly with block printing, which lays down less ink than silk-screening. You can add white or thickener to the paint to counteract this, but this often affects the consistency of the ink, and it can be hard to pull a print that's not mottled or blobby. Instead, exploit the transparency of the ink, printing on darker fabric for a subtle effect or with unusual colors (red on green fabric, for instance).

3

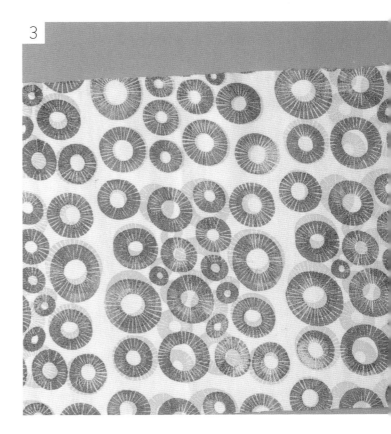

1

Adding spot color

If you're adding spot color to an overall design, you can print those bits individually (for instance, a different-colored flower). Mark the back of the block, either with a cross so that you can center the block over a space, or mark the points on the edges that you want to match up.

Printing on ready-made items

Beware of seam lines—don't try to print over them, as the different thickness of fabric will show in the print as varying degrees of pressure, picking up more or less ink. Either avoid these areas, or unpick the item, print, and then sew it back together. The same thing applies to hems on skirts and so on. Stenciling is also unpredictable over bumps.

If you're printing on a bag, shirt, skirt, or similar double-layered item, be sure to place something inside it, like folded newspaper, to separate the layers of fabric. This not only ensures a smoother surface but also prevents ink from bleeding through.

If you're printing fabric to sew, it sometimes makes sense to cut the pattern pieces out before printing, so you can be sure the prints are placed where you want them and you don't spend ages printing fabric that you won't use. It's also easier to correctly cure smaller pieces of fabric.

Printing large pieces of fabric

Fold over the bits you're not printing, so that the part you are printing lies flat. Block prints dry relatively fast, which means you can pile up the printed part without smudging.

If you're printing large pieces based on a grid structure, at the very least mark horizontals and verticals at intervals on the fabric with a disappearing marker as a reference so that you can correct slight misalignments before they get worse.

Curing very large pieces of fabric in the oven can be difficult. Moisture needs to evaporate from the fabric before the ink can start curing, and ovens can be too humid an environment for this to happen properly. Tumble drying the fabric before curing in the oven will help, as can ironing.

1 One overall-pattern block and one spot-color block

MAKING THE BLOCK

by Jesse Breytenbach

Supplies

- Paper
- Pencil
- Marker or pen
- Soft rubber linoleum block
- Carving tools (U- and V-gouges)
- Masonite board
- Box knife and blades

1 The design can be drawn directly onto the linoleum, or onto paper first and then transferred. If it's not a symmetrical design, the drawing will need to be reversed, otherwise it will print in reverse.

2 Trace the outlines of the drawing with a soft pencil, then place it face down on the lino and tape it down. Rub the back of the drawing firmly with the back of a pen or a spoon, or something similarly hard and smooth. Lift a corner to check that it's transferring and that you haven't missed any spots. Remove the drawing from the lino.

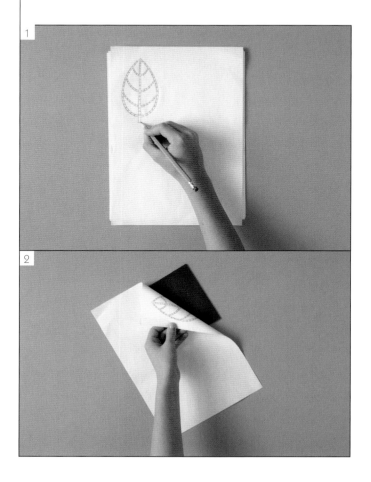

3 The pencil lines can easily smudge, so if there's a lot of carving to do, draw over the lines in pen. Let it dry. It helps at this stage to color, hatch, or mark with an X any solid areas, so that you don't carve them out by mistake.

4 Special lino-cutting tools work best. Use the V-gouge to cut around the drawn shapes, and the U-gouges to carve away anything that doesn't need to be printed. Be careful not to cut under your lines; it's better to slant gently outward from the lines. The block will print more cleanly and last longer. Cut fairly deeply; blocks for cloth, especially textured cloth, need to be more raised than stamps made for paper. Use a craft knife to trim any excess around the edges.

5 Lay thin paper on top of the block, and rub a soft pencil over it, covering the whole surface. See if there are parts "printing" that shouldn't be.

Stamp pads are another quick way to test. Dab the stamp pad evenly over the surface of the block, then put the inked block face down on paper, pressing firmly and evenly.

6 To give the block rigidity, glue it to masonite board. Trace around the lino block, then cut the board to size using a box knife. It's useful to leave a small margin around the design for ease of handling, but don't make it too wide. Glue the block in place and leave it to dry. I use basic white PVA glue and leave the block overnight under some heavy books. Use the broad U-gouge to smooth the edges so they won't pick up ink when you print.

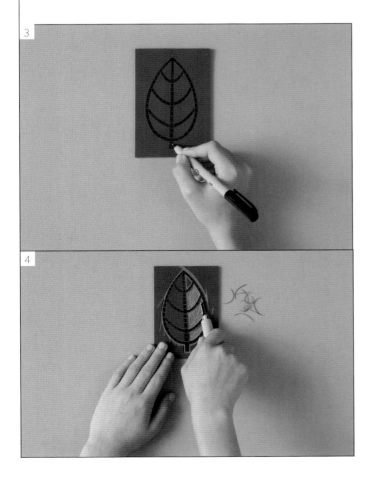

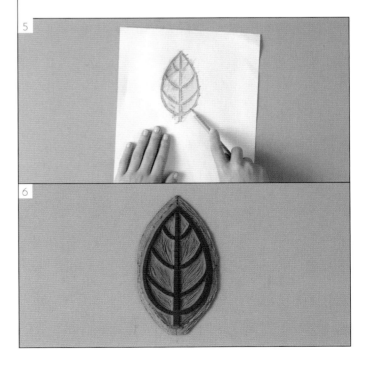

BLOCK PRINTING

by Jesse Breytenbach

Supplies

- Water-based fabric paint/silk-screen ink for textiles
- Smooth surface for rolling out ink (glass, tile)
- Smooth surface for printing
- Scooping tool
- Paper for cleanup
- Natural fiber fabric, washed and ironed
- Iron for curing
- Apron

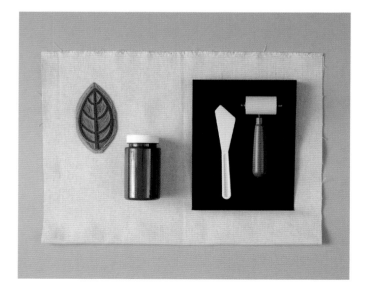

1 Scoop about a tablespoonful of ink onto the glass. Picking up a little bit at a time with the roller, roll it out until you have a smooth layer and the roller is evenly coated. Roll ink onto the block. Check that only the raised parts of the block are inked. Wipe excess ink off, especially on the edges. (If you're constantly inking parts of the block that you don't want inked, you may need to cut these away further.)

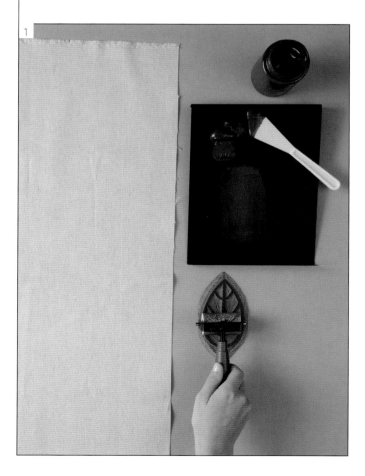

2 Do a few test prints to get a sense of how much ink to roll onto the block to get a good print; the first print is often light. Also test how much pressure you'll need to apply.

Pick the block up by the edges and place it face down on the fabric, being careful not to shift it as you do so. Press down on the back. If the block is big you can use a rolling pin.

3 Pick the block up by lifting it straight up—don't tilt it as you lift. Use your other hand to hold the fabric down when lifting the block, as it might stick a bit.

4 Repeat, wiping the edges of the block occasionally. When the prints are dry, cure according to the ink manufacturer's instructions.

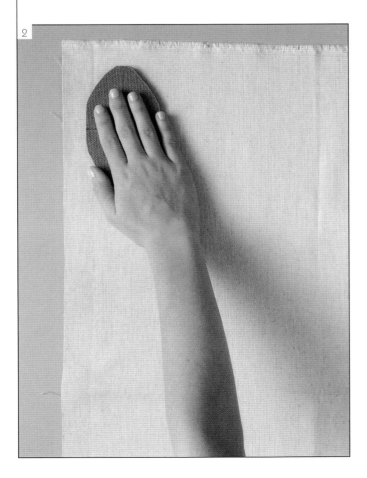

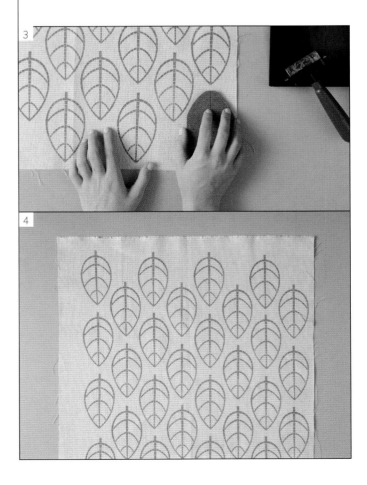

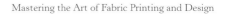

BLOCK PRINTING: SIMPLE REPEATS

by Jesse Breytenbach

Random repeat

1 Some designs don't need much planning. Ink the block and start printing, working out the spacing as you go.

- Mark the back of the block: Draw lines on the front of the block from the main points. Continue these over the edges of the block, and use a ruler to join them up on the back.
- Print motifs close together or wider apart across the whole piece, or vary the spacing as you go. Twist the block for more variation.

Basic grid pattern

2 A grid pattern is one of the simplest layouts that will ensure a fairly even spread of motifs. There are many possible variations and ways to approach grids. You can mark the fabric before printing, using a disappearing marker and a ruler to measure blocks.

Alternating grid pattern

3 By printing a motif in alternating squares, a brick or half-drop repeat can be achieved. The brick repeat is achieved by dropping the motif halfway horizontally, and the half drop is created by printing the motif halfway vertically to the next image.

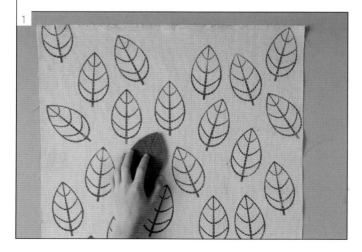

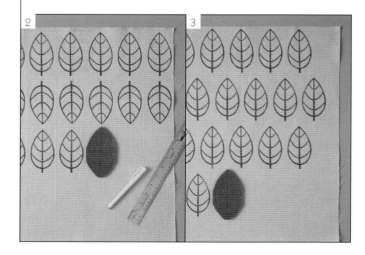

Other grid patterns to explore

- Print a motif in each square.
- Print a stepped grid by printing a row in each square, then printing halfway across each square for the next row.
- Print along each drawn line, rather than inside the square, for a checked pattern.
- Change the orientation of the block for even more variations: At intervals, print the motif upside down or slightly rotated.

Finger spacing

4 Grid patterns can also be printed quite accurately without marking up the fabric.

- Using the straight edge of the fabric as a guide, start printing in one corner.

- For the next print, ink the block and, before you put it down, use the back of your other hand to measure how far away from the first print to place the block: two fingers, one finger, the width of your palm.
- Repeat for the whole row and then use the same method to place the prints in the following row. (Hover the block over the fabric before placing it, to get the spacing right.)

Margin spacing

5 You can use the margin left around the block (or the margin of a stencil) as a guide for distance. For stepped grid patterns it's particularly useful to mark the midlines of the block; this makes it easier to line it up with the middle of the previous print.

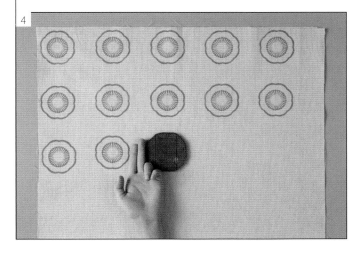

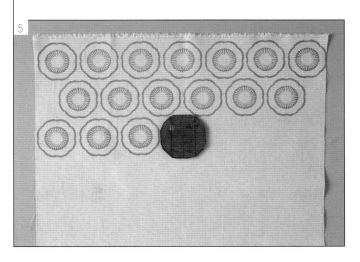

BLOCK PRINTING: COMPLEX REPEATS

by Jesse Breytenbach

In order to create more rich and complex prints, one or more blocks can be used together. Combining blocks to incorporate several designs is a way to create a more complex repeat.

Complex repeats: Alternating motifs

1 To create a grid pattern with more than one motif, use two different blocks. Print the alternate motif at each point that it's needed.

Composite blocks: Design on paper

2 You can set up a bigger block with several motifs that is a component of an overall design. An example is a block with four identical elements. Work out the design on paper: Draw, photocopy, or cut and paste the basic repeat of four motifs, with at least one motif around the basic cross-shaped repeat.

Lino block

3 Transfer this design to the lino block, remembering to reverse it. Cut the lino block exactly to size, do the major cutting of the motifs, and measure and cut a piece of board exactly the size and shape of the lino cross-shape. Glue the lino to the board. When it's dry, trim away excess lino around the edges, and round the edges of the board, but do not cut the basic shape any smaller.

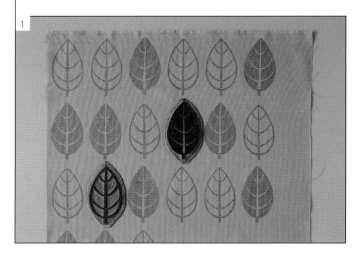

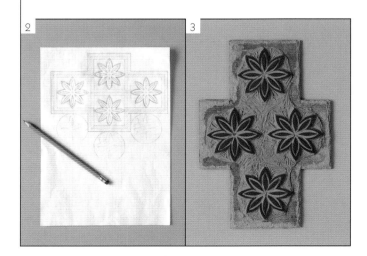

Printing: Second repeat lined up

4 Print the first repeat in the top corner. To print the next one, hold the inked block just above the fabric, line it up so that the edges meet the previous print, and lower it straight down to print. There'll be gaps around the edges of the fabric when you're done, and you'll need to print the relevant parts of the block in these gaps to fill in the repeat.

Movable type block

5 Carve a variety of motifs, all the same size, and cut one master block from the board. Don't leave margins around the small lino blocks, and mark the positions on the master block. Swap and change the lino blocks for different prints using the same format.

A composite block doesn't have to be just one unit of the repeat; if it's a small-scale pattern, a block can be set up with two or four repeats of the pattern.

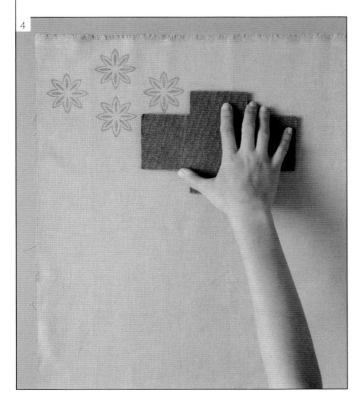

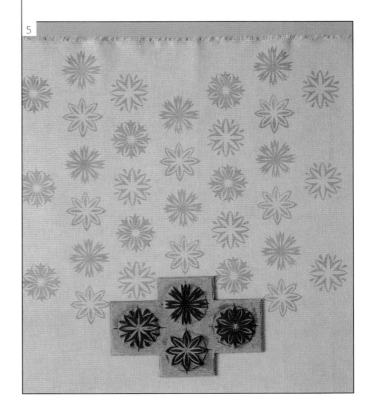

STENCIL PRINTING

by Jesse Breytenbach

Supplies

- Thin, stiff plastic (e.g., overhead projector sheets or plastic folders)
- Sponge or sponge roller
- Smooth surface for rolling out ink (glass, tile)
- Smooth surface for printing
- Scooping tool
- Craft knife/scalpel
- Water-based fabric paint/silk-screen ink for textiles
- Natural fiber fabric, washed and ironed
- Paper for cleanup

1 First draw your design on paper. Then take your sheet of plastic and tape it to the paper so your drawing is showing through. Next, cut away all the parts that you want to print. It's important to ensure that all small parts are attached at some point, not floating free in the middle of a hole.

Try to break up large print areas too, as it can be difficult to achieve consistent color coverage across these. Too many large holes can produce a floppy stencil that's hard to lift cleanly. Leave enough space around the edges of the design to be able to handle the stencil without getting ink on your fingers and to provide a safety margin when printing so that you don't print over the borders of the stencil.

Place the washed and ironed fabric on a flat surface.

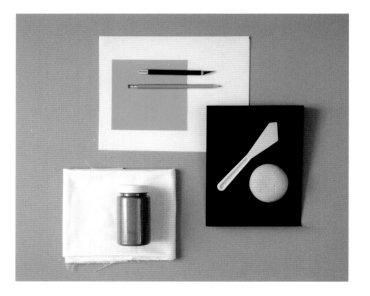

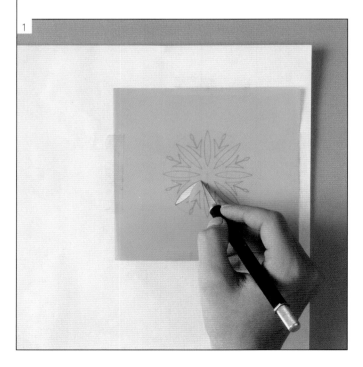

Paper stencils

Thin cardstock will stand up to some repeated use, but paper stencils are only really good for one use. Another alternative is freezer paper.

2 Scoop some ink onto a sheet of glass, then pick some up with the sponge. Dab the excess off onto the glass, then, holding the stencil down firmly with one hand, press the inked sponge onto the fabric gently but firmly. Don't wipe sideways; the biggest problem with stencils is keeping the ink from creeping under the stencil and blurring the outlines. Don't use too much ink at first; experiment to see what kind of coverage you get.

3 Lift the stencil smoothly, without pulling it across the print.

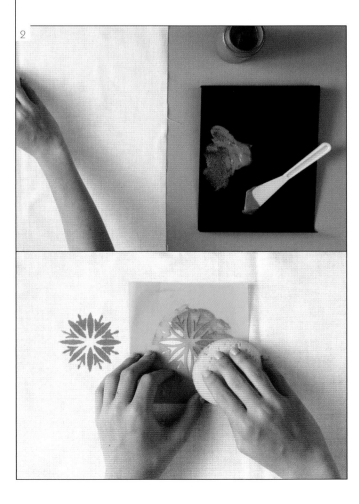

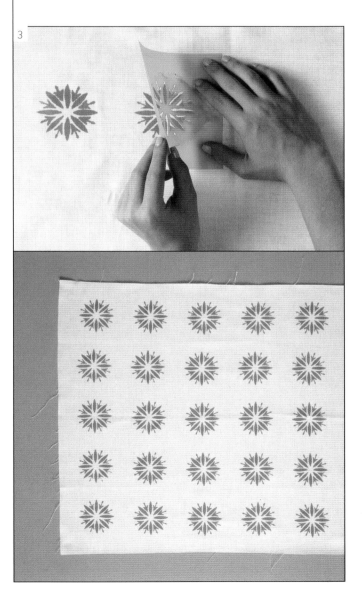

131

MAKING A SMALL STENCIL FRAME

by Jesse Breytenbach

Supplies

- Postcard-size wooden picture frame
- Stapler and staples
- Thin, loosely woven fabric for a screen (nylon net curtaining/voile)
- Stencil
- Packing tape
- Scissors

1 Measure the frame, and cut a piece of fabric about 2 in/5 cm bigger all around. Lay the frame on the fabric. The back of the frame should be on the fabric, particularly if the front of the frame is curved or beveled.

2 Pull the middle of one side of the edge of the fabric over the frame, and attach by stapling it to the frame.

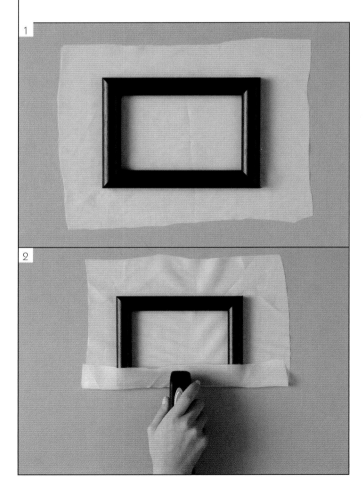

3 Do the same on the opposite side, stretching the fabric taut. Repeat on the remaining two sides.

4 Pull the fabric tightly across the frame and attach it to one side of the first attachment point. Repeat on the opposite edge, reversing the position. You should now have six staples in your frame.

5 Attach the rest of the fabric in the same way, working outward toward the corners, and always making sure that the fabric is stretched tightly across the front of the frame. Trim away excess fabric, but not too close to the staples. Seal the inside edges of the frame with packing tape.

6 Tape the stencil to the front of the screen. It's helpful to tape the bare parts of the screen with packing tape, which gives you space to park unused ink while you move the frame to the next printing position.

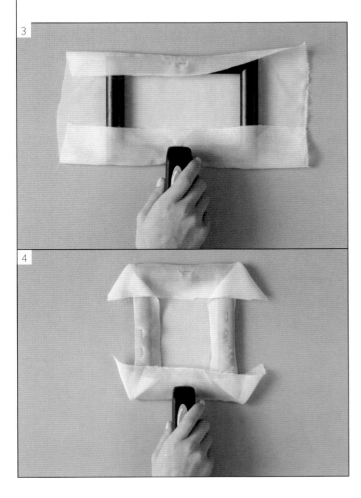

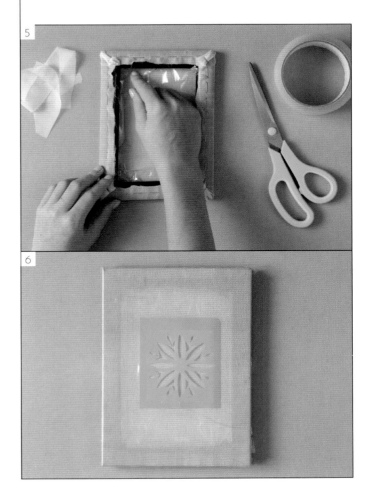

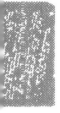

PRINTING WITH A SMALL STENCIL FRAME

by Jesse Breytenbach

Supplies

- Screen from previous tutorial
- Washed and ironed fabric
- Water-based fabric paint/silk-screen ink for textiles
- Small squeegee (such as an old credit card)
- Sponge
- Scooping tool
- Smooth surface for rolling out ink (glass, tile)
- Smooth surface for printing

1 Scoop a small amount of ink onto the glass plate. Place frame stencil-side down on the fabric and hold it down firmly. With your other hand, scoop a small amount of ink up with the credit card and tap it onto one end of the stencil border.

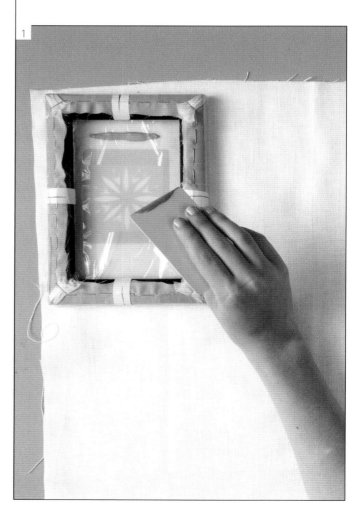

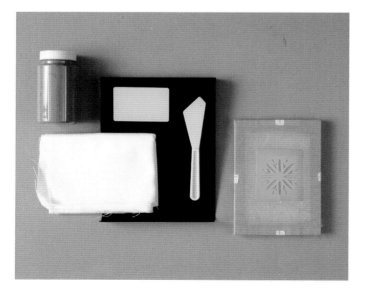

2 Lightly and smoothly draw it across the stencil. You might have to do this a few times. You can also use a sponge to print, dabbing the ink through the screen.

3 Lift the frame.

4 To line up repeated prints more accurately, you can mark the edges of the frame with tape in much the same way that the backs of the printing blocks are marked.

Cleaning up

Pull the stencil off the screen and wipe off excess ink. Remove the tape from the screen and rinse the screen out under a running tap. Hold it up to the light to check that there's no ink stuck in it.

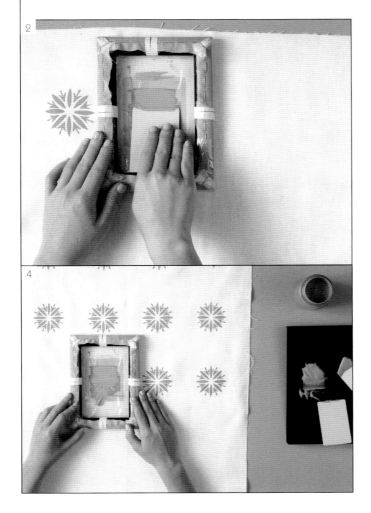

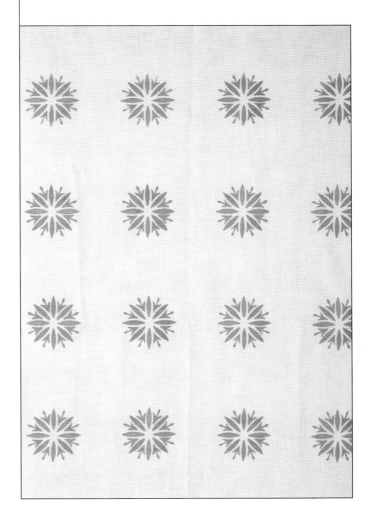

INTERVIEW
Jesse Breytenbach, Jezze Prints

Jesse Breytenbach is an illustrator, printmaker, and comic artist living in Cape Town, South Africa. She does illustrations for educational books and has an impressive list of clients she's worked with on freelance illustration projects. For her printing on paper, she uses a small press she picked up at a local market. Also a talented textile designer, Jesse hand prints fabric on her kitchen table using hand-carved blocks of her own design. She has also published a graphic novel called *I Don't Like Chocolate*. Jesse's relief prints, textiles, and sewn products are available through her website.
www.jessebreytenbach.co.za

Q: How did you get started with printing fabric?

A: I wanted fabric for myself: I thought sewing might be less intimidating if I worked with cheap fabric I printed myself. My mom used to linoprint T-shirts for us when we were little, and I already knew from art school that I hated silk-screening, so I started experimenting with block printing. Not having a lot of space to work in, I worked with interchangeable motifs that could be printed on any size fabric and overprinted for variation. Now, a few years later, I'm still expanding on my original prints, and I still haven't printed fabric for myself to sew with.

Q: What is your favorite part of the process?

A: Very hard to say. I love cutting the blocks, but I also really love printing, and trying out different color combinations as I go. Probably the best moments are when I start printing a design and realize that it could work in a completely different arrangement, and with different colors. The beauty of my low-tech printing method is that I can try the new idea right away, and that's a thrill!

Q: What do you do when you are suffering from lack of inspiration?

A: Usually the dishes, but if that doesn't work, I start going through my stacks of old drawings. Often I find an abandoned

1

1–3 Block-printed fabric, button covers,
cotton tape, and trim

Q: What advice would you offer someone who wanted to get started with hand printing fabric?

A: Don't be scared to experiment. Find out as much as you can about ink and fabric; visit the manufacturer's websites, email them, phone them, ask questions. Try different inks and fabrics and printing blocks, print swatches, wash them thoroughly. Try again! Oh, and wear an apron when you're printing.

idea that sparks a whole series of new ones. Sometimes it takes hours of stubbornly fiddling with a drawing before it becomes a design I want to use. But I keep all the failed attempts, too, for when I'm stuck.

Q: What do you find the most challenging about designing fabric?

A: Seamless repeats. I get around that by printing motifs.

Q: And the most rewarding?

A: The geometry and rhythm of patterns. The way different colorways can change the mood of a design completely.

3

PROFILE
Jun Shirasu
www.shirasstudio.blogspot.com

Jun Shirasu is a veteran ceramic tile artist and accomplished printmaker who specializes in *aquatint*. Aquatint is a complex process for creating incredibly detailed tonal values in a print. The result is an effect that is reminiscent of a beautiful watercolor or wash.

Aquatint is accomplished by applying acid to a copperplate to create the printing plate. What makes this process so unique is that instead of using a carving tool to make the lines that print, aquatint uses an acid-resistant powdered resin that is manipulated to create the design. When the design is complete, the plate is exposed to acid, which bites around the resin granules, leaving channels for the etched lines. The tonal variations in the printing are controlled by how long acid is exposed to a specific area.

Jun lives in Higashi-Murayama, a suburb of Tokyo, Japan, with his family. His passion for his work is evident in his extensive collections, which have been exhibited worldwide during his twenty-plus-year career. His daily studio commute is further evidence of his commitment to his craft: a ten-minute bicycle commute—up the hill on the way there and down the hill on the way home.

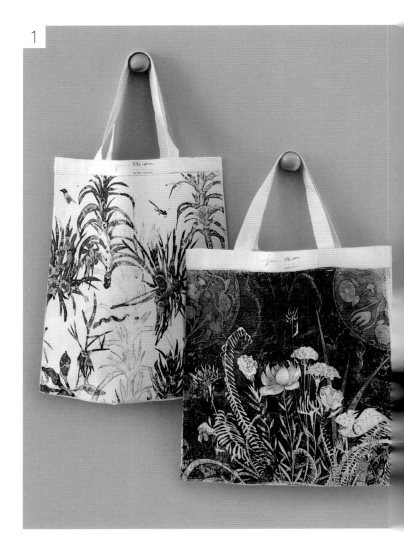

1

1 These totes were created by printing directly onto cotton bags using an aquatint copperplate and Persian blue French Charbonnel etching ink

PROFILE
Lotta Helleberg
www.inleafdesign.com

Lotta Helleberg is a textile artist with a background in graphic design and printmaking. The beauty of nature is a constant inspiration and a common theme in Lotta's work. She works primarily with linen and utilizes a technique in which fresh leaves and other plant material are used as printing plates, coated with paint and pressed onto fabric. These impressions are incorporated into quilts, fabric collages, and a variety of functional and decorative objects.

Paint is applied to the back of the leaf with a foam brush or roller. The leaf is then positioned on the fabric, covered by tissue, and pressed down with a brayer (a type of hand roller). Slight variations in each impression create a unique replica of the original leaf. Leaf printing lends itself to wonderful experimentation. Some leaves become abstract shapes, others will depict intricate veining detail.

Lotta was born in Sweden and now lives in Charlottesville, Virginia, with her family. She exhibits her work in several regional galleries.

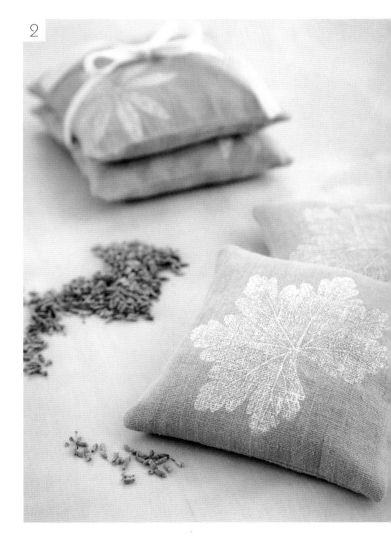

2 Geranium and sweet woodruff leaf-printed sachets on hand-dyed linen and filled with lavender

SCREENPRINTING

I've been lucky enough to be able to take several courses in screenprinting, and it's nothing short of addictive. It's a wonderful way to be able to hand print an unlimited number of nearly identical prints. One of the most lovely aspects of screenprinting is the crisp lines that you can achieve by printing through a screen.

1 Rows of crafty boys and girls hand screenprinted on linen by Shannon Lamden of Aunty Cookie

2 Bird in Paradise fabric by Amy Prior for Umbrella Prints. Hand screenprinted on organic hemp/cotton

3 Hand-dyed, screenprinted, embroidered, and appliquéd chair by Laurie Wisbrun

4 Poppies screenprinted fabric by Danielle Stewart Design. Features magenta-colored ink on sand linen/cotton base cloth

5 Fabric designed and hand screenprinted by Amy Prior anc Carly Schwerdt for Umbrella Prints

5

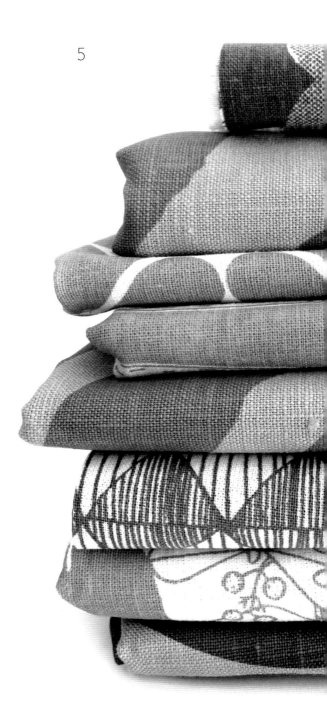

THE SCREENPRINTING PROCESS

by Lara Cameron, Ink & Spindle

The design process

I love the challenge of designing for screenprinted textiles. The medium itself and the production method each pose different challenges and limitations when it comes to the design process.

First and foremost—catering for the screen repeat. When printing textiles by hand, there is always a margin for error. No two repeats side by side will ever be positioned with complete accuracy. And this of course means you have to create a design that doesn't depend on complete accuracy. For example, you couldn't print a vertical stripe, or a design that doesn't have any clear breaks in it. So you really have to conceive your designs with this limitation in mind. The other thing to consider is that if two repeats aren't lined up perfectly, then your design needs to be able to absorb and hide this error.

The other challenges of designing for screenprinting come from the medium itself. Each color in your design needs to be separated and exposed onto its own screen. Screens are expensive (especially yardage screens!) so our designs are usually only single color or two color. Registration is also an issue when it comes to multiple colors. So we design in such a way that tight color registration isn't required.

Finally, the individual fabrics you are printing onto also affect the artwork. A heavy canvas-weight fabric is more suited to larger-scale prints with details that aren't too fine, whereas a lightweight jersey can accommodate fine line work.

Creating a screen

There are many methods for creating a screen. We use the photographic exposure method because it's accurate, fast, and easily replicable (despite being rather expensive).

The first step is to print your artwork onto film as a positive. This artwork needs to be at a scale of 100 percent and printed with an opaque black ink that is dense enough to block out light. Smaller films can usually be printed on a home inkjet printer with good results. Larger films like those used for yardage need to be printed by a specialist large-format printer, which is costly but worth it for the results.

We provide the artwork to our film house as either an Illustrator or Photoshop file. The artwork needs to be black and white. Not grayscale—black lines and fills only.

1 Ink & Spindle screens drying
Image © Marcel Lee

Once the film positive has been produced, it's then used
to expose the screen. We don't expose screens in-house
at Ink & Spindle purely because the equipment required
to expose yardage screens is too large and costly, and it's
better left to the experts.

1

Printing

Once the fabric is rolled out onto the table, we lift the screen up onto the table and position it beside the first "stop." When printing we always need two people, one on each side of the table and at each end of the screen. Let's call them printer #1 and printer #2.

Printer #1 is in charge of pouring the ink. The ink is poured in a line at one end of the screen.

The first thing we do is called a "flood pass." The purpose of the flood pass is to fill the screen mesh with ink before each print, ensuring a clean, even print.

A squeegee is placed behind the ink. Printer #1 holds the squeegee at a 45-degree angle and pushes it toward printer #2. For a flood pass this is done lightly with no downward pressure on the mesh. At the midpoint, printer #2 takes the squeegee, maintaining the same pressure and angle. She pulls the squeegee toward herself, completing the first pass.

Now that we've flooded the screen, the screen is lowered onto the fabric so there is actual contact between the fabric and the screen mesh. Printer #2 turns the squeegee around and passes the squeegee back to #1, this time with a little bit of downward pressure. The ink is then pushed through the mesh onto the fabric. We usually do two or three of these "ink passes," and then a "dry pass," which is where the squeegee is pushed across the screen without any ink. The dry pass is used to push the ink into the fabric and scrape off any excess.

Once all the passes are complete, we lift the screen off the table and then move it along to the next position. Straightaway we need to flood again, because any time the screen is elevated and exposed to the air, ink is prone to drying in the screen.

It's important to note that when printing yardage, you can't print each adjacent print one after the other. Because the repeats overlap slightly, and the width of the screen is wider than the artwork itself, printing two repeats side by side would make the underside of the screen dirty and also potentially smudge the previous print. Therefore we print repeats 1, 3, 5, 7, and so on, and then once they're touch-dry we come back and print 2, 4, 6, 8, and so on.

Finishing

Once a full run of printing is complete and touch-dry, it needs to be heat-set in order to be washable. We send it off to a dye house that has a large tunnel oven (like a pizza oven of sorts!). Smaller pieces of fabric can be heat-set with an iron, and we've heard that a hot tumble dryer can work as well.

1 Wrens in Inky Blue

2 Tegan and Lara printing fabric yardage

INTERVIEW
Lara Cameron and Tegan Rose,
Ink & Spindle

Ink & Spindle is a small boutique yardage screenprinting studio based in Kensington, Melbourne, Australia. Owned and operated by Tegan Rose and Lara Cameron, Ink & Spindle designs and prints a range of textiles onto organic and sustainable fabrics in an ethically responsible manner. Working collaboratively, the pair have made a name for themselves as design innovators in the world of hand-printed textiles. Ink & Spindle's fabrics are available through its lovely online store.
www.inkandspindle.com

Q: How did each of you get started with screenprinting?

A: We both came to the industry with somewhat unconventional backgrounds. Lara has a background in multimedia and graphic design, but completed a short course in screenprinting and loved the more tactile nature of working with textile. Tegan has a background in fine arts where she minored in printmaking and also spent some time teaching art, textiles, and animation at secondary-school level.

We met through a mutual friend, and after establishing that there was definitely a market for ethical, hand screenprinted textiles, we took the plunge and started to build our studio.

Q: How do the pair of you collaborate on designs?

A: We often discuss creative ideas whilst we're printing. Printing is manual work that requires two people, so there's lots of opportunity to bounce ideas back and forth—and gossip! When one of us is working on a new design, she'll show the other and get feedback, and continue making changes until we both think it's ready.

Q: Any advice on ways to collaborate effectively?

A: I think you have to appreciate each other's strengths. It's also so important to not be too precious about your work. You have to be open to feedback and other ideas and letting go of the creative process a bit.

Q: What is your favorite part of the design and printing process?

A: I love the entire creative process, but my absolute favorite part is when a design that's been mulling around in my head for days/weeks/months finally turns into something real. Sometimes it can be so hard to turn an idea into reality. And then for it to work as a textile design is another challenge.

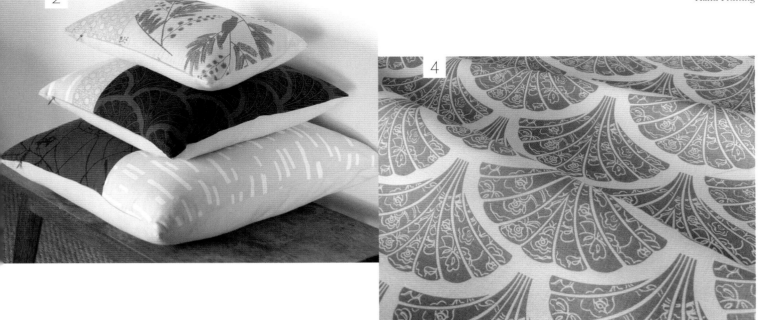

Q: What do you find most rewarding about designing fabric?

A: I find it so rewarding to see what other people create with our fabrics. Sometimes it's easy to lose appreciation for something you've designed yourself and see every day. It's hard to see our textiles with fresh eyes. But when someone creates something and sends us a photo, it's like seeing our textiles in a whole new light. Especially when they've created something we'd never have thought of!

Q: What advice would you offer someone who wanted to learn to screenprint?

A: Anyone can learn to screenprint; it's what you do with the medium that matters. I think that it's a highly rewarding process—you're producing at a "batch" scale, which means you can do really short runs of highly creative, experimental pieces, or you can produce larger runs with a more commercial mindset. I think it's important to remember, though, that the creative element is a very small part of what we do. Most of our time is spent printing, doing admin, packing shop orders, e-mailing customers . . . This is true of any small business!

If you'd like to learn to screenprint, I highly recommend doing a short course in screenprinting. Screenprinting can be quite messy and all sorts of things can go wrong—it's deceptively simple. Having a good setup and learning tips and tricks from an expert is invaluable.

1 Birch Forest

2–3 Ink & Spindle's Tamarillo collection

4 Lace Fans

CHAPTER 6
DIGITAL PRINTING

Technological advances have completely changed the landscape of fabric printing. From printing fabric at home on an inkjet printer to small-scale runs of professionally printed fabric using industrial digital printers, fabric printing has become accessible to a whole new audience.

Spots by Laurie Wisbrun

ADVANTAGES OF DIGITAL PRINTING

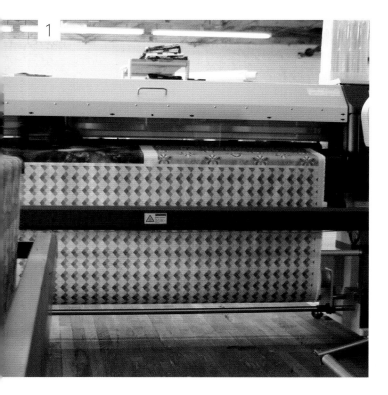

When I discovered digital fabric printing, my eyes lit up and I could hardly contain my excitement. The ability to affordably print small quantities of fabric with my own designs? And have that fabric in my hands in just a few short weeks? The possibilities seemed endless. And as I've learned more about digital printing and begun to understand more about how it all works, I'm still a strong believer in printing fabric digitally, as it's opened up a whole new world of possibilities for me and loads of other fabric-oholics out there.

Spoonflower, launched during the summer of 2008 by Stephen Fraser and Gart Davis, was the first digital fabric printing company targeted specifically to crafters, DIYers, and independent designers looking for a way to produce fabric on demand in very low volumes. It is the printing company I first started working with, so much of this book's content on file preparation and color management is based on that experience and on Spoonflower's production specifics. But there are other companies who provide similar digital fabric printing services, so I encourage you to explore and find the company whose services best match your needs.

1—2 Digital textile printers at Spoonflower's headquarters in North Carolina

2

Advantages of digital fabric printing

- **No minimums:** Most fabric you find in quilt and craft stores is screenprinted. These commercially screenprinted fabrics are generally manufactured with a minimum print run of several thousand yards and produced in Asia. With digital fabric printing, as little as a swatch or a fat quarter can be printed, because there are no screens to create and thus no setup costs.

- **Speed:** Digital printing makes it possible for designs to go from a computer screen to fabric within a matter of minutes. Digital services vary in how quickly they can fulfill orders, but from the time you upload your designs, you can generally expect to receive your printed fabric within a few weeks.

- **Nearly unlimited colors:** When screens are created for commercially printed fabrics, each color in the fabric requires its own separate screen. Since digital fabric printing doesn't use screens, there is no need to limit your designs to a small number of colors. The only restriction related to colors is the range of colors that your printing service can produce.

- **Experimentation:** Screenprinting limits the size of repeats in textile designs because—in the case of rotary screenprinting—a repeat can be only as wide as the circumference of the screenprinting cylinder. So in addition to allowing the use of thousands of colors, digital printing allows artists to create very large designs without traditional repeats. This frees you to experiment with nontraditional textile designs.

- **Environmental impact:** One of the advantages of digital printing is that it leaves a very, very small footprint. Digital print services produce only what you need, and the amount of chemicals, water, and energy required to produce your fabric is fairly insignificant compared to textile industry norms.

WORKING WITH A DIGITAL PRINTING SERVICE

When it comes time for you to choose which digital printing service you are going to work with, here are a few items to consider.

Turnaround times

Most services can deliver your fabric within several weeks. Some offer a rush service that can deliver fabric within two to three days.

Setup costs

Most digital printing services do not charge setup costs unless you are requesting additional services related to preparing your artwork for printing or color matching.

Types of base cloth

As on-demand digital fabric printing becomes more advanced, more and more base cloths are being offered by printing services. Each company offers a different range, so check to see which service prints on the type of fabric you need. Although cottons (quilting weight, sateens, broadcloths, and canvas) are generally the most popular, don't limit yourself. You may think of different applications for your designs if they're printed on linen, silk, rayon, fleece, or satin.

Applying color

Learning the basic differences between pigments and dyes will help you understand how color actually gets applied to the fabric by a digital printer. This is a highly simplified description of the process but does provide a high-level overview of each approach.

In general, digitally printed fabrics are somewhat more delicate than their mass-produced, screenprinted counterparts. The idea is to produce fabrics that are comparable to screenprinted fabrics in terms of durability, but you may find that some digitally printed textiles need to be dry-cleaned, and some cannot be washed at all without risking significant fading. You should rely on the service you use to provide washing instructions for the printed fabric. But there are also considerable differences between fabrics digitally printed with dyes and those digitally printed with pigments.

1

Water-based pigments

Pigments are solid particles of color suspended in water. When the printers apply the color to fabric, the color particles sit on top of and around the fibers of the fabric. Polymer binders hold the color in place and allow them to adhere to the fibers. Because these inks can be applied to untreated fabric and only require heat-setting after printing, this is a more environmentally friendly printing method than dye-based printing. No additional chemicals are used in the printing or preparation process, and there is no excess ink that gets washed into the water supply.

The most significant variable in the pigment printing process that can affect how the pigments bind to the fabric is the fabric itself. If the fabric has foreign residue on it such as a softener (most likely so small that it's not visible to the naked eye), some pigment particles may not stick to the fabric. Your fabric printer will work diligently to source the cleanest fabrics possible so these problems don't occur, but if you find that your fabric isn't holding color, you're likely experiencing one of these problems:

- **Crocking:** Color comes off fabric when two pieces of fabric are rubbed together
- **Bleeding:** Color comes off when the fabric is either washed or is exposed to humidity or perspiration

Dyes

Dye particles actually bond with the fabric's fiber on a molecular level and change the color of the fabric itself. Dyes do tend to result in more saturated colors than pigments, but there are downsides as well. Fabric must be pretreated to accept the dye, which means more chemicals are used. Excess dyes must be laundered from dyed fabric and then heat-set, which adds to the environmental impact, time, and expense of dye printing. For these reasons, dye-based digital printing is generally more expensive and time-consuming than pigment-based printing. Keep in mind that while dyes are not as prone to crocking as pigments, they can also exhibit some fading and bleeding.

In summary, dye-based printing produces fabric with deeper, more saturated color that is less prone to fading and crocking than pigment-based digital printing. But it is also more expensive to produce, so experiment with different printing services and find the approach that most closely fits your needs and your budget.

DESKTOP INKJET PRINTING

Especially if you're in a hurry to get started on your project and need your fabric right now, these do-it-yourself approaches to fabric printing are a fun and fast way to create printed fabric in low quantities. There are several ways to transfer your designs to fabric using an inkjet printer or inkjet copier. Most stores will carry several brands of textile transfer papers and printable fabric sheets, so read the package directions to find the brand that's right for your project.

Transfer paper

Print or copy your artwork directly onto the transfer paper. Then, when the image is dry, use a hot iron or press and apply the paper directly to the fabric. When using transfer paper, some brands will have a "plasticky" finish, so be aware that some papers will change the hand of your fabric (the way your fabric feels). Look for descriptions like "super soft finish" if you'd like something that will leave a more natural hand.

Be mindful that when you're using transfer paper, any area of your design that is white or not covered by your design will allow the color of your fabric to show through. So if you're applying your transfer to anything other than white fabric and don't want the color to show through, consider using opaque transfer paper as an alternative.

Pretreated fabric paper

You can't simply put a sheet of fabric in your printer like you would a regular piece of paper. In order to print directly on fabric using your inkjet printer or copier, it needs a firm backing.

Fabrics that are pretreated and printer-ready have been specially treated so that the ink from your printer will penetrate the fabric's fibers and run smoothly through most brands of inkjet printers. There are a wide variety of brands of ready-to-print fabric papers, but the most

common fabrics available are cotton, linen, and silk. Some brands will require steam-setting and others will have an adhesive backing. Choosing which type of fabric and which brand to use will be dependent on your project and how you plan to use your fabric.

The size of the fabric sheet you can print will be determined by the size of your inkjet printer. But even using a standard 8½-×-11-in/21.25-×-28-cm sheet, you can print sections of fabric that are ample for most small projects. If your printer has the capability to print banners, you can print scarves or long pieces of fabric by using rolls of fabric instead of individual sheets.

Self-adhesive fabric stabilizer

InkBloom has created a fabric stabilizer called Loomtack that can be applied to nearly any fabric, allowing it to run through your printer. InkBloom has a set of base fabrics that they have tested for best use, but the stabilizer can be applied to your own fabric, greatly expanding the types of fabric you can print using an inkjet printer. Cut a piece of fabric to fit in your printer tray, then apply the stabilizer to the fabric. Load the fabric sheet into your printer, print your design, and peel off the stabilizer. Your design is printed directly onto the fabric and you can sew with it like any other printed fabric.

1 Lonely Socks laundry room bin by Laurie Wisbrun. Label created using transfer paper, and then it was top-stitched to a store-bought fabric bin

2 Fabric design by InkBloom. Printed on fabric using Loomtack and used to cover pocket journals

3 Love chart design by InkBloom. Printed on fabric using Loomtack and sewn into a keepsake pouch

COLOR AND DIGITAL PRINTING

As I was learning about color management and digital printing, it was always a bit of a guessing game and crossed fingers to make sure my colors turned out as vibrant as I had envisioned. This overview and the tutorials on the following pages should help you better understand how to work with color and set up your files. I promise that the extra effort is worth it. It's very disappointing to open your mailbox, find that your fabric has arrived, and open the package, only to see that the fabric doesn't look like you had expected. But have no fear: It is easy to solve your color dilemmas with a few simple steps.

Although printing digitally on fabric means you don't need to limit your designs to a specific number of colors (like you would for a screenprinted fabric whereby each color requires its own screen), there are some limitations to the actual colors themselves that can be produced with digital fabric printing. An out-of-gamut color is one that can't be produced by your printer. It's much better

to know what those colors are and be able to adjust your files accordingly (or even better to build your original files using only in-gamut colors) before you place your fabric order, as it will save you money, time, and a headache.

Color-management tips

• **Find out which color model your printer uses:** You might recall from Chapter 1 that color models are different "systems" for numbering and displaying colors so they can be communicated to your printer. One of the first things you should find out when working with your printer is what color model it uses. Your printer should list its color model in any guides or FAQs the manufacturer provides. Most likely files will need to be set up in CMYK or in RGB.

When you're creating your design files, working in layers or vector art will make color modifications a much quicker process. It's always easiest to start your design using the color model you plan to use for your output. Although most graphics programs can convert a file from one color model to another (from CMYK to RGB, for example), doing so risks creating subtle changes in the colors in your file.

• **What you see isn't always what you get:** Since your computer monitor displays color in the RGB color model, even if you have your file's colors set to the specific model requested by your printer, what you see on your monitor or what you print out on paper may turn out differently from what gets printed on fabric. You may also see slight differences in color when you print on different base cloths, as light is absorbed by different types of fabric in different ways.

Another general tip when thinking about color and digital printing: Very saturated colors, absolute blacks, and neons will likely be less saturated than you might expect. Stay away from large solid areas of dark colors, as you may observe banding where the fabric looks irregularly striped.

• **Take advantage of color-management tools provided by your printer:** To reduce the opportunity for color disappointments, take advantage of the tools provided by your fabric printer. Most of the digital fabric printing services will provide you with several tools you can use for color management.

• **Electronic color libraries:** These are electronic files you can download from your printer and load onto your computer to use as a swatch library in the software you're using to create your art. Using these libraries ensures the colors in your art will fall within your service's gamut, meaning they are producible by their digital printers.

1 Printed color guides from Spoonflower and Fabric on Demand

- **Printed color guides:** Most printing services offer printed color guides. These are printed pieces of fabric that show how the colors from your printing services' electronic library will look when they are printed on fabric. Each printed swatch will be labeled with the corresponding color codes for that specific printers' color model. When used in conjunction with an electronic color library, you'll be able to see what a specific color looks like both on screen and printed on fabric. The colors in these guides were selected for their true rendering, meaning that each one is within the color gamut of their printers, and these colors will print on fabric very similarly to how they will look on screen.

To simplify your color management, make sure your file is set up in the correct color mode and load any digital library files from your printer before you start your designs. Then you can simply select colors from the electronic library (and compare them to your printed color guide) as you go. Using the two tools together allows you to compare what you see on screen and see what your colors will look like when they're printed. If you begin your artwork designs using those tools as a guide, you will be much less likely to have color surprises when you receive your fabric.

In the case where your file wasn't originally set up using an electronic library and/or a printed color guide, you can go back and adjust your colors after your design is complete and before you send your files to the printer. It's really important to have a printed color guide in these cases though, so you have something printed to reference for actual color.

But it's very important to note that these tools will only contain a representative palette of colors. What this means is that even if the color you'd like to use isn't in a printer's color library or color guide, it may still be possible for their equipment to print the color you're hoping for. So if you find that there is a color in your design that doesn't have an exact match from your printer's color library, leave it in your design. Just make sure you print a swatch before you order yardage and know that color is at risk to shift, meaning it may print differently than you imagine. The only way to know for sure is to give it a go!

- **Test swatches:** As a last check, you should always order a test swatch of your fabric. This will allow you to see how the colors in your specific design will turn out when printed on fabric. You might also consider ordering a piece of fabric large enough both to check your colors and to make sure your repeat is coming together seamlessly.

File formats

When you're exporting your artwork for your printer, each printer will accept a range of file formats. Depending on which one you choose, your file will be compressed in different ways. There are two types of compression: lossless and lossy.

- **Lossless compression:** A TIFF is an uncompressed file format for graphics. Even a very small design can result in an enormous TIFF file that may be too large to upload to a website. PNG is an intermediate format that does compress a file, but it does so in a way that, unlike JPEG, does not degrade the quality of the design itself. As a result, it's a bit hard to predict how much compression the PNG format will offer because it depends on the file itself. In some cases a PNG version of a design will be much smaller than a TIFF, but in others it may offer only a slightly smaller file size.

When exporting in either of these formats, none of the information from your file is removed, meaning these formats will have the least risk for color shifting. As a rule, PNGs are much better for uploading than TIFFs. The only reason to use a TIFF is if you're trying to work in LAB color model, which is only supported by TIFFs.

- **Lossy compression:** These have a smaller file size, as compression discards some information from the image. Although changes are very small, some detail can be removed, which can lead to blurry edges and shifting colors.

Every printer will have a maximum file size that can be uploaded for printing, so you may have files that require that you save them as a JPEG in order to meet these file-size requirements. In these cases, it is highly recommended that you print a swatch before you print yardage so you can check your colors and your art. If you have a very large design, then you will almost certainly need to use JPEG compression, which will make even very large designs manageable.

Be aware that each time you make a change to a JPEG, whether in size or any other respect, and then resave it, the quality will deteriorate slightly. If you can work with another format for the original (i.e., Illustrator or Photoshop), and then export to JPEG as a last step, then you'll protect the integrity of your file details.

The next two tutorials will show you how to adjust files for printing gamuts after you have created your artwork. Even if you create your files using your printer's color library, you may decide to change a color after your artwork is complete.

ADJUSTING FILES FOR PRINTING GAMUTS USING ILLUSTRATOR

What you will learn
- How to load a color library from your printer
- How to replace a color
- How to export your file for production

Software used
- Adobe Illustrator

Specifications

Each printer will have different file specifications.
Spoonflower recommends the following:

File formats: JPEG, PNG, or TIFF

File size: Your image must be smaller than 30MB

Resolution: 150 dots per inch

Color model: RGB

Loading a color library from your printer

1 Start by opening your artwork file. Next download the electronic color library from your printer. For Illustrator you will need the .ase file format. As I mentioned previously, I use Spoonflower as my printing service, so for this tutorial I will show you how to use their color library in Illustrator. In the Swatches menu, select Open Swatch Library>Other Library. Find the .ase file and click Open.

2 The library will open and includes all swatches provided by Spoonflower that are in gamut. If you hover over a specific swatch, it will show you the RGB values that you can use to compare to your printed color guide.

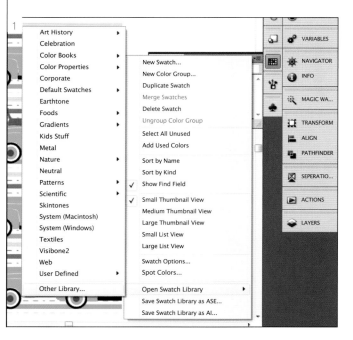

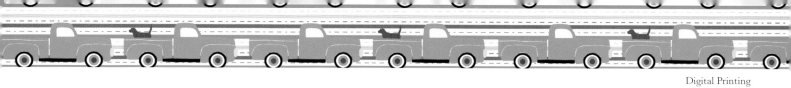

Recolor your artwork

3 If there are colors that you'd like to change, you can use Illustrator's recolor artwork functionality. Select>All. Edit>Edit Colors>Recolor Artwork. Click on the down arrow at the bottom of the menu and select the color mode your printer uses (e.g., RBG for Spoonflower). Click on the grid at the bottom of the menu and select your printer's library from the list. This will limit the colors you are using to the ones from your printer's library.

4 In the Current Colors list, click on the color you want to change, then click on the Color Picker. This will bring up only the colors in your printer's library, from which you can choose a replacement. Click OK to apply the changes. If you have a printed color map, find the replacement color on the map to see how it will print.

Resize your artwork

5 If you need to change the size of your artwork, you'll want to do this before you export your file. Select>All. Object>Group. You can use the Height and Width boxes near the top of your screen to change your file size if you need to.

Export your file

6 File>Export. In the Save File Type menu choose TIFF (or JPEG or PNG) and click Save.

7 Make sure Color Model is set to RGB. Set Resolution to 150 dpi. Uncheck Anti-Alias. (Note: If you check this box you may end up with dithering in your file.) You can leave LZW unchecked. (Tip: If your file exceeds the 30 MB file limit, try checking this box for lossless compression and then recheck your file size.) For Byte Order select IBM-PC (Spoonflower's equipment is PC-based). Uncheck Embed ICC Profile. Click OK.

8 Upload your file to your printer.

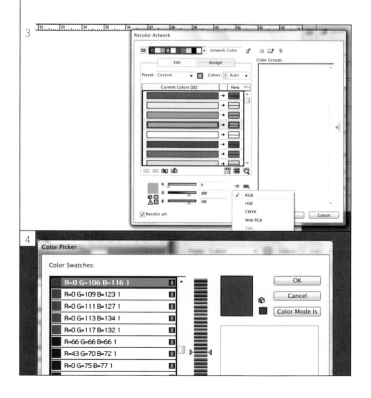

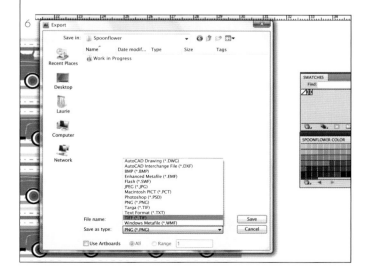

161

TOUCHING UP A SCANNED IMAGE USING PHOTOSHOP

What you will learn
- How to make small touch-ups to scanned images
- How to load a color library from your printer
- How to replace a color
- How to export your file for production

Software used
- Adobe Photoshop

Specifications
Each printer will have different file specifications.
Spoonflower recommends the following:
File formats: JPG, PNG, or TIF (8-bit, uncompressed)
File size: Your image must be smaller than 30MB
Resolution: 150 dots per inch
Color model: RGB

After an image is scanned and has been digitized, you may need to do some minor touch-ups. You may find there are edges you need to clean up to make sure everything tiles seamlessly.

Adjust levels

1 If you drew your art in pencil, you may need to darken the lines in your drawing so they are more defined. Image> Adjustments>Levels. Slide the arrow on the far left of the input levels area to the right until you reach good definition of your lines. Click OK.

Loading a color library from your printer

2 Start by downloading the library. For Photoshop you will need the .aso file format. As I mentioned previously, I use Spoonflower as my printing service, so for this tutorial I will show you how to use their electronic color library using Photoshop.

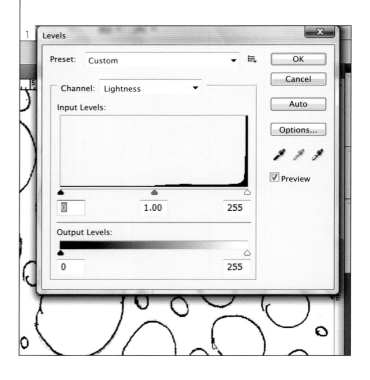

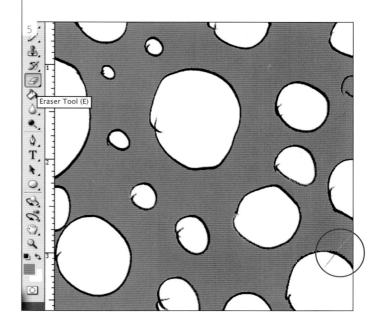

Tip

If your Pencil, Eraser, or Paint Bucket Tools stop working, you likely have an object selected somewhere on the page that is not allowing your tools to be active. Select>Deselect and you should be able to use your tools again.

3 In the Swatches menu, select the down arrow and select Load Swatches. Find the .aso file from your printer that you saved to your computer and click Load.

The library will open and includes all swatches provided by Spoonflower that are in gamut. Use the Eye Dropper Tool to select a color that you can use to add a background color to your file.

Add a background color

4 To add a background color using the color you selected with your eye dropper, use the Magic Wand Tool and select the background. Then use the Paint Bucket Tool to fill the background with your selected background color. After you fill the background (mine is orange), you may notice that some of the circles were also accidentally filled with color. This means the circles weren't closed (there are gaps in the lines) and we'll need to fix each one.

As you clean up your file, you'll want to zoom in on each area and use the following tools.

Eraser tool

5 Use the Eraser Tool to clean up any edges where you can see seams or edges of your paper.

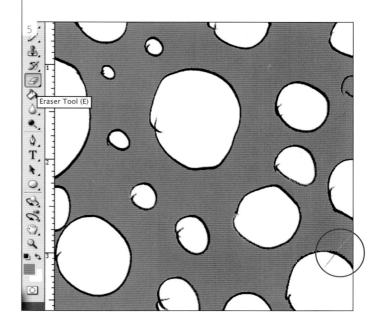

Pencil tool

6 Use the Pencil Tool to draw lines and close up any gaps in your design so you can fill those areas with color.

Paint bucket tool

7 You'll need to toggle back and forth between your background color and your foreground color depending on what tool you are using. To fill an area with a color, select it using the Magic Wand Tool, make sure your background color is set to the color you want to use, and then use the Paint Bucket Tool.

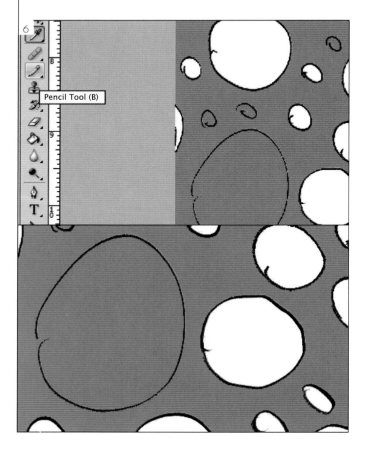

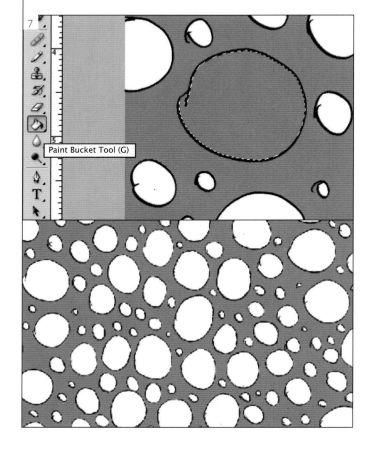

Export your files for production

8 First we'll set the color mode: Image>Mode. Select RGB and 8 Bits/Channel.

9 Next we'll set your image size and dpi: Image>Image Size. In Resolution, enter 150 and select pixels/inch. Click OK.

10 Finally, we'll export our file. File>Save As. In the Format menu, choose TIFF (or JPEG or PNG) and click Save.

In Image Compression you can select None. (Tip: If your file exceeds the 30MB file limit, try selecting LZW for lossless compression and then recheck your file size.) Under Pixel Order select Interleaved. For Byte Order select IBM-PC (Spoonflower's equipment is PC-based). Click OK.

11 Upload your file to your printer.

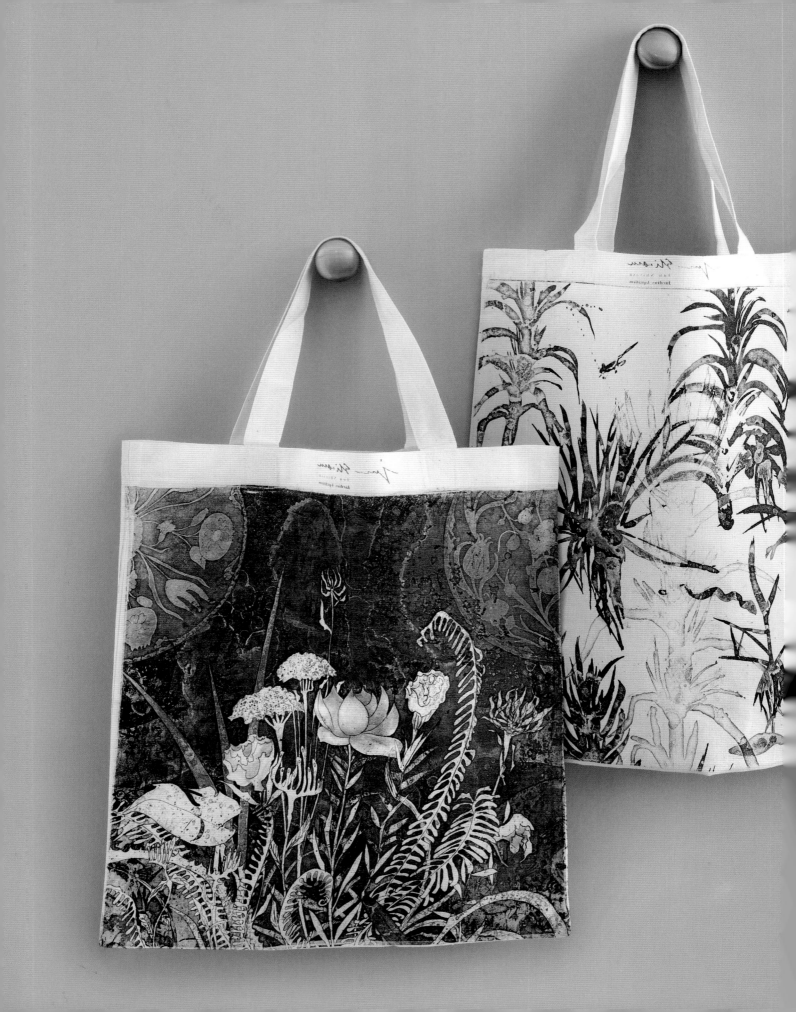

CHAPTER 7
GOING PROFESSIONAL

If you've got an entrepreneurial spirit and are considering self-producing your own fabric line, this chapter will give you a starting place for your exploration. From professional printing options to higher education for formal training to marketing approaches to building your brand, I hope this information proves helpful in charting your path.

Tote bags by Jun Shirasu

MASS PRODUCTION: FINDING AND WORKING WITH A CONVERTER

Self-producing your own fabric for mass production is a big commitment. It means ordering hundreds or thousands of yards of fabric printed with your designs. So if you're considering going down this route, make sure you have a clear plan in place for how you'll be manufacturing your fabric and distributing it for sale. The expenses and lead times for producing your own fabric can be sizable, so make sure you've got a solid business plan defined before you make this kind of cost and time commitment. Not only will you need to have the cash flow to front the production costs, you'll also need to build a plan for how you'll get your line into as many retail channels as possible.

The Small Design Company's Guide to Wholesale Fabrics

Published by Fashiondex, this wholesale fabric sourcebook is written for small businesses looking to source fabric and materials. It includes a directory of companies who will sell to a business with low minimums. A minimum is the smallest order you can place. Although the book is written primarily for apparel manufacturers looking to source different fabrics, the guide also includes a list of mills and converters. If you're looking for a way to get your fabric printed in production-level commercial quantities, this guide is a great place to start.

www.fashiondex.com

Mills

A weaving or knitting company that manufactures fabric and textile goods. It's unlikely you will start with a mill, as most have minimums of between 1,000–5,000 yards, depending on where they are located. U.S.–based mills generally have the highest minimums, followed by Asia and Europe.

Converters

A converter purchases greige goods directly from a fabric mill. These greige goods are simply raw fabrics that a converter purchases and then dyes, prints, or finishes for their customers. Converters may specialize in a single area (e.g., printing) or they may provide multiple types of conversions (e.g., printing and embroidery). Although converters offer lower minimums than mills, most will still have minimums between 500–1,000 yards per order. You'll need to research converters who offer custom printing services.

1 Fabric at a textile mill ©iStockphoto.com/gerenme
2 Bolts of fabric ©iStockphoto.com/George Clerk

INTERVIEW
Nancy Mims, Mod Green Pod

Nancy Mims is cofounder and creative director of Mod Green Pod. Prior to Mod Green Pod, Nancy was a highly successful textile print designer for nearly a decade. Represented by agents in New York City and Los Angeles, she has sold more than 1,400 of her original designs to retailers, manufacturers, and converters around the world. Frequently cited in the design press for her unique approach to textiles and her personal style, Nancy enjoys combining her keen sense of color with her belief that a healthy home need not be a boring one. *www.modgreenpod.com*

Q: What is your design background? How did you get started designing fabric?

A: My formal education through graduate school was in science, art, and art history. I arrived at surface design by lucky chance, when a textile designer friend in Los Angeles recognized my eye for pattern and color and suggested that I try selling some of my designs through various print houses in Los Angeles and New York City. I never regret the circuitous path I took to get here because everything I have learned contributes to my process as an artist and designer.

Q: What was your path to manufacturing your own fabric?

A: After working as a freelance surface designer for eight years, I wanted more control over everything, from the designs and colors to the manufacturing process and the final products. I realized that there was a giant hole in the market for high-design sustainable textiles, especially ones with bright, bold patterns, so I quickly worked to fill that niche. I also wanted to support the struggling U.S. textile industry, so I worked with my business partner and sister-in-law, Lisa Mims, to pioneer a U.S. supply chain that followed the highest organic standards.

We started Mod Green Pod by selling our fabric and wallpaper strictly to the trade, and decided that the high price point for hand silk-screening would work best for our business model. Various factors, including a growing desire from wholesalers to buy our fabrics, helped us make the decision to switch to rotary printing.

1

1 Mod Green Pod wallpaper and organic cotton fabric

2 Aspire sofa against Delight wallpaper

3 Butterfly Jubilee

4 Aspire

Q: What are the biggest challenges you've faced in working with a converter/printer?

A: Some of the big advantages to working with U.S. mills are speed and quality control; we are relatively close to our mills, which allows us to get things done quickly. The only drawback we've experienced is with our inks. Because we abide by the Global Organic Textile Standards (GOTS), we are very strict about only using inks that are GOTS-approved, and at this time, we have only been able to source those from Germany. The German source mixes our colors to order, so we sometimes experience a delay in getting those inks from Europe to our mill in the United States.

Q: How does your emphasis on sustainability affect the way you design and produce your work?

A: I always aim to create appealing designs and colors that are unique to the overall market, so that the sustainability factor is just an added bonus for those who are simply drawn to the designs. Many of our customers find us because they are seeking sustainable textiles, but others find us because they are looking for beautiful, chic-but-timeless prints for their homes. I love designing at that intersection because, for the time being, there are few of us here, but the hope is that one day all textiles will be sustainable.

Q: What advice would you offer to someone considering producing their own textiles?

A: Spend a lot of time creating and editing your collection. Once you think it's ready for production, start by having some digitally printed samples made so you can see the designs and colors on actual cloth before you go into larger production. Once you have figured out your supply chain, get to know all of the people involved in that process and learn as much as you can from them. Making those personal connections really helps make things easier and more enjoyable. If you can, work with factories in your own country so you can have control over quality, communications, and ease of visiting the mills yourself. Do what you can to make your product and/or process as sustainable as possible.

Q: What advice would you give to someone who wants to get into textile design?

A: Do as much work as you can and never throw away any of your old work. I have returned to my old, often embarrassingly awful work so many times and completely redeemed it. I'll notice a line or concept that I hadn't appreciated before; then I'll rework it as something new. Sitting down to a blank page is incredibly difficult, so starting off with a problematic old design is often a better way to go.

3

4

INTERVIEW
Heather Ross

Heather Ross is an illustrator and author, with clients in publishing and manufacturing. Her design background includes 10 years as the founding designer and president of Munki Munki, followed by seven years as an illustrator, author, and fabric designer. Based out of New York City, Heather's fabric designs for FreeSpirit Fabrics and Kokka of Japan celebrate her love of nature and themes from her childhood in northern Vermont. Heather also authors a blog where she inspires and educates on ways to live creatively and integrate sewing into one's home and lifestyle in a stylish and modern way. *http://heatherross.squarespace.com*

Q: How did you get started designing fabric?

A: I have always loved fabrics, and even as a kid I was always seeking out conversational and novelty prints in shops and vintage stores. I first began designing fabric for Munki Munki. I developed the brand as a way to combine my interest in clothing design and fabric printing. I was 26 years old and had taken a few classes in textile printing and printmaking, and loved doing it enough to try to develop a business around it.

Q: When you started Munki Munki, were you manufacturing your own fabric?

A: When I started Munki Munki I had never used a computer before. I was living without electricity in Northern California. My father gave me an ancient Apple IIfx, a digitizer, and a stylus, and a copy of Photoshop. I had to rent somebody's garage so that I would have a place to plug it all in. I knew enough about the screen-making process in fabric printing to know that if I could draw my designs in Photoshop—and divide it into channels—I would be able to maintain more control over my artwork, test my repeats, and adjust colors easily.

Q: How would you describe your design style?

A: I would describe my style as naive. I like to keep things happy, nostalgic, pretty. Much of my work draws on my own childhood, which was mostly spent in the woods of northern Vermont. My own experience was actually pretty dramatic; my family struggled against extremes, both in climate and poverty, but we were always surrounded by such shocking beauty, and my sister and I were given such remarkable freedom. We sought out what all children seek out: joy and humor and sweetness.

1 Mendocino by Heather Ross for FreeSpirit. The collection was inspired by the years Heather spent on the rugged and remote coasts of Northern California

Q: Where do you look for color inspiration?

A: I struggle with color. I bought a small carton of strawberries in Switzerland because they were the most perfect color I had ever seen and spent an hour trying to successfully photograph them, but couldn't do them justice. I also spend a lot of time looking at kids' books from France and Germany; there is something about those inks, those colors . . . I have worked with companies in different parts of the world and have come to believe that we all see color differently. Nowhere does hot pink like India, for example, and the best yellows come out of France. Switzerland, obviously, has perfected red.

Q: Do you have any "oops" stories you can share? The kind of thing you might do differently if you had a chance to do it over?

A: My biggest mistake was in thinking that I could build a career around licensing. I lost a few years professionally there. Eventually I got tired of sitting in meetings and being told "you won't actually be making any money by giving us your artwork to use on our products, but it will be great for building your brand," and looking around the room and realizing I was the only one there who was having this compromise forced upon them. I became very weary of never knowing how much I would earn from any project until two years after I did the work, and of being asked to develop products that seemed neither useful nor beautiful, and seemed largely to be vehicles of all of that artwork that I was handing over for the sake of brand building.

Then I realized that what it's always been about for me was the drawing, and the storytelling, so I've really tried to focus on that for the last two years, and it seems to be working. If I could do it over again, I would have gone to a great art school, where perhaps I would have learned to be a great illustrator. That's really my only regret and it's a very old one.

Q: What advice would you impart to a fledgling textile designer?

A: Be yourself. Avoid the common mistake of trying to model your business or your art around the work of another person. And remember one of my most favorite sayings: Don't overestimate what you can accomplish in a single year, and don't underestimate what you can do in five.

HIGHER EDUCATION

There are numerous education options for continuing your textile studies. They range from design-centric programs to those that emphasize the science and engineering aspects of textile manufacturing. These programs provide students with an opportunity to work with fibers across a broad spectrum of study and may expose you to an aspect of fibers and textiles that sparks a new category of interest. Internships are often part of the study curriculum, allowing you to work in professional environments and experience what it's like to work in a specific part of the industry.

The Textile Society of America maintains an extensive list of colleges and universities offering textile-specific education. The list includes degree programs and distance-learning options from around the world. *www.textilesociety.org/opportunities_education.htm*

Examples of some of the courses of study from several universities are listed on the right. Although not a comprehensive list, this demonstrates the many aspects of textile study.

- Apparel manufacturing, marketing, and distribution
- CAD
- Computer jacquard loom
- Conservation
- Cultural and social aspects of dress
- Dyeing
- Entrepreneurship
- Ethnic textiles
- Evaluation of fabrics and apparel
- Felt making
- Fibers, art, and design
- Historic costume and textiles
- Properties of fibers, yarns, and fabrics
- Surface design
- Textile chemistry
- Textile engineering
- Textile technology
- Weaving

1 Modern Meadow fabric birds
© Joel Dewberry 2010

2 Hot Blossom fabric collection by Josephine Kimberling for Robert Kaufman Fabrics Photography by Natalie Grimmer of natalie g. | photography www.nataliegphotography.com

3 Hand-printed fabrics by Hitomi Kimura of Kalla Designs

FULL-TIME CAREER OPTIONS

Careers might include

- Apparel Stylist
- CAD Designer or Technician
- Design Consultant
- Fabric Development Specialist
- Lace Designer
- Knit Designer
- Marketing or Sales Representative
- Print Designer
- Production Equipment Operator
- Textile Designer
- Textile Engineer

As a textile designer, there's a breadth of career directions you can follow. Most frequently, textile designers design fabric that is used in the manufacture of clothing, home décor fabric, rugs, bed and bath linens, and other products. But textile designers also work in other areas, like the paper products, or home décor industries, designing patterns and artwork for product packaging, wallpaper, giftware, paper party goods, wrapping paper, and stationery.

Depending on where you are in your career, a day in the life of a full-time textile designer might include some or all of the following:

- Researching new trends and textile/graphic patterns
- Collaborating with clients, a design team, or marketing or buying staff
- Developing new designs (freehand drawing, CAD, Adobe Photoshop, Adobe Illustrator)
- Creating mock-ups of how designs would look on products
- Creating repeats
- Sourcing fabrics and other materials for production
- Revising and recoloring designs for production
- Project management
- Meeting with design and production teams

1 Dressmaker's mannequin with tape measure
©iStockphoto.com/Anna Chelnokova

2 Model wearing Deer Valley dress. © Joel Dewberry 2010

3 Models on the catwalk at a fashion show
©iStockphoto.com/webphotographeer

INTERVIEW
Julia Rothman

As a freelance designer, Julia Rothman's talents are evident in the quality and breadth of work she creates. Specializing in pattern, and hand-drawn and digital design, Julia's work has graced editorial pages in prominent newspapers and magazines, and has been licensed for a long list of products including wallpaper, bedding, and stationery. In 2002 Julia joined forces with Matt Lamothe and Jenny Volvovski to create Also, a digital design company that creates websites for small and independent companies. Julia works out of her studio in Brooklyn, New York.
www.juliarothman.com

Q: What is your design background? What was your first paying job as an illustrator?

A: I graduated from the illustration department at Rhode Island School of Design in 2002. During my sophomore year I interned at *City* magazine and they gave me my first real illustration job, drawing a New York–style coffee cup for their back page called the Icon page. They loved the illustration and asked me to make it a regular thing. So even after my summer internship was over, I was illustrating that Icon page at school and emailing it to them. I got paid very little, but it gave me a huge amount of exposure and a lot of work for my portfolio when I graduated.

Q: What made you take the leap to becoming a freelancer?

A: After graduating I went to live back home until I could save enough money to move out. I looked for full-time jobs at design companies, but my portfolio was all illustration so it was hard to convince companies that I knew anything about type and layout—which I really didn't! I put up a website with all my illustration work and sent out a postcard to market myself to magazines, and eventually I started getting work. *Teen People* magazine became a regular client, and eventually I started making enough to support myself. So I've never had a regular full-time job since leaving RISD. I just jumped right into freelance.

Q: What was the path to starting Also?

A: I was illustrating a catalog cover for a company that makes high-end dog apparel and products. They asked me if I ever designed websites, which was new terrain for me. I had asked my friends Jenny and Matt, who graduated from RISD, to help me with my own site, so I figured they could help me with this project as well. Together we created a really fun website where I illustrated all these funny dogs in sweaters and they animated them and built out the site. We worked together so well that we decided to start a company together.

3

Q: Can you describe some of the differences you find in designing for textiles versus other mediums?

A: When I create designs for textiles, scale becomes very important. Usually when I've designed bedding it gets blown up five times bigger than I'm used to looking at on my computer screen and 10 times bigger than I originally drew it. I always print my design at several sizes to compare the slight differences. I use a lot of detailed line work in my patterns, and when the line gets blown up big I always have to make sure it still looks nice.

Q: What is the most challenging thing about being a freelancer and working for yourself?

A: I've found the business side of freelancing to be the hardest part. I am good at marketing myself, but then when I get the job, I never know what to charge. I have a hard time negotiating and I've done a lot of jobs for less than I probably should have gotten. I am getting better though!

Q: Do you have any "oops" stories you can share? The kind of thing you might do differently if you had a chance to do it over?

A: When I first started making patterns I decided to do Surtex, the licensing and design trade show. I sold all of my designs for $500 each and totally lost the rights to them. Companies used the designs for whole lines of products. One major catalog company used one of my designs for about 20 different kids' products in their next season's catalog. It didn't take long for me to realize I shouldn't sell the rights to my work away and that I should license my designs. I still smack myself on the head thinking about how I sold away some of my favorite first designs.

Q: What advice would you give to someone who wants to get started as a surface and pattern designer?

A: If anything I would stress the importance of marketing yourself. There are so many blogs now that hundreds of thousands of people read every day! It's so easy to send an email with a few images. That's how I've found all my work. I get emails from companies who saw me featured somewhere online.

INTERVIEW
Kerry Cassill

Kerry Cassill designs and manufacturers fabric, bedding, and clothing that are hand-dyed and hand block printed on superluxury-weight Indian cotton. Known for her beachy, bohemian style, Kerry first began by designing blouses and scarves, which later blossomed into her home bedding and upholstery collections. Her prints are globally influenced with extremely elegant color combinations. She also has a retail shop in Laguna Beach named lala: a Kerry Cassill boutique. *www.kerrycassill.com*

Q: What is your design background?

A: I was born in Northern California in 1960 and later moved to Seattle and became a flower child of the 1970s; I spent my days watching *Bewitched* and daydreaming about the future. As I grew older, I developed a passion for the arts and studied apparel design in Seattle and later in Los Angeles. My education and love for fashion led me to Paris, where I became obsessed with the soft cotton and look of Indian textiles.

Q: When did you start printing your own fabric?

A: I was working in Seattle and had a millinery shop. I was selling shirts, then called Rocker Shirts, a blouse on printed cotton. I wanted more control over what prints I was selling and decided to explore printing my own fabrics. Through a series of happy accidents, I was put in touch with a printing house in Jaipur, India. And to this day I continue to have my fabric printed in Jaipur.

I live in Laguna Beach where the light is particularly lovely, and it's particularly known for its pink light. Jaipur and Paris are also pink-light cities. It's important for a colorist like me to be able to pull both from my experience and from my environment when coloring my patterns.

1 Paisley label bedding featuring Kerry's characteristic
rich palettes

2 An example of the lush prints from one of Kerry's
clothing collections

3 Medium Orange Floral

4 Deep Floral

Q: As you design patterns for apparel, home, bedding, and upholstery, how do you decide which patterns to use for each part of your collection?

A: At the beginning of the year I'll design upwards of 150 prints. The prints then get sent off to India, where blocks are created and samples made. When I get the samples a few months later, my focus is on coloring and spacing my patterns so each collection rhymes. I'll then narrow the prints to roughly 75 designs, which I'll then divide into six or seven groups to be released throughout the year.

I don't follow any hard and fast rules around what prints should be used for which application. Prints that I would personally want to wear are more likely to become apparel patterns, and prints that I would want in my home are probably going to become home, bedding, or upholstery prints.

Q: Where do you look for color inspiration?

A: When looking for color inspiration, things are always changing for me. Whether it's life at the beach, a garden, or even something as small as a teacup; I'm drawn to colors with many pigments. I love colors with depth. When coloring my prints, I focus on mixing colors and layering prints in a comfortable, relaxed way that's meant to put people at ease. Using a balance that's not all "bright bright" or "cool cool," you need to balance with one soft or one warm. I design my prints to collect from year to year, as they're meant to be timeless and never go out of fashion.

This year my palettes are more mellow and more soothing. It's what I need in my life and what I want to put out there for people to put into their own homes. The layers are more refined and easy.

3

4

APPROACHING FABRIC MANUFACTURERS

I'm often asked for advice on how to approach manufacturers. Just like any interview you've ever been on, it's all about preparation, timing, skill, and finding a fit.

Remember that the design teams at the major fabric manufacturers receive hundreds of submissions each year and license a very small number of designs they receive. It's important you present yourself professionally and make sure your art is applicable for what they produce and for their market.

Understanding licensing

When a manufacturer licenses artwork, it means they are paying the artist for the rights to use the artwork on the goods they manufacture. The artist is then paid royalties against the sale of the goods, which allows the artist also to profit from the success. In the world of fabric, manufacturing royalties are paid based on the number of yards of a design printed.

Do your research

Before you start reaching out to manufacturers, do your homework and get to know as much about them as you can. Look at their websites, visit retail stores that carry their lines, and read news about them. Manufacturers aren't looking for more of the same. They're looking for unique and different styles that don't overlap with what they already produce; so consider how your designs

would "fit" within their design range. Some manufacturers' websites have details on how they prefer to receive design submissions. Read their guidelines closely and make sure you're addressing each point in what they've outlined.

Develop a portfolio

Like any industry in which you are presenting your art for review, it's important that you develop a portfolio of your designs. Make sure you take the time to consider how your art would actually translate to fabric. Although it's not a requirement for all manufacturers that you submit your art in repeat, it won't hurt.

- Include enough work to demonstrate your personal design style and your capabilities. Consider including ten to fifteen designs
- If possible, submit your designs as complete collections rather than as individual prints
- If you create your art using multiple approaches (hand drawn, painted, digitally generated), include designs that represent that versatility

Once you've decided which designs to include in your portfolio, take a step back and review it with a critical eye. When you look at the pieces you've selected, do they tell a cohesive story and communicate who you are as a designer? Do the color palettes you've included help to

reinforce your identity as a designer? Edit carefully and only include work that helps to show off your skills and personal style. You're hoping to seek a balance that communicates your focus but also demonstrates your breadth and versatility.

Digital vs. printed portfolio

Depending on how a manufacturer prefers to be contacted, and how you decide to present your art, you may be submitting your work digitally or you may be submitting a printed presentation. Regardless of which approach you choose, make sure every image or page you include is clearly labeled with your name and either your email address or your contact information. That way if a single image or page is somehow separated from the group of work you submit, you can still be contacted.

If you're submitting your work via postal mail or presenting it in person, make sure your printouts are high quality and look professional.

If you're sending a link to your website, make sure your pages are well designed to show off your work, and that the pages load quickly. If the files are too large or your website is hard to navigate, you may lose the opportunity to show off your designs.

Don't be afraid to try something different and unique. If you have a creative approach to showcasing your designs that demonstrates your personality and amplifies your work, go for it! But make sure your presentation is professional and that it makes it easy for someone to review your designs. If someone has to work too hard to see your work or your presentation detracts from your designs, you may want to rethink your presentation.

Don't give up!

Although manufacturers receive a slew of submissions each year, most are always on the lookout for new talent. So even if you submit your designs and they're rejected, don't give up! If you receive any feedback on why your work wasn't a fit, take that into consideration and see if you can modify what you do accordingly. And keep trying! As you develop more and more work, consider resubmitting it to manufacturers. Your next batch of work might be just what they're looking for.

INTERVIEW
Joel Dewberry

A prolific designer, artist, and craftsman, Joel Dewberry launched his textile brand in 2007, and it continually inspires consumers. He is uniquely able to harmonize an eclectic mix of design styles into cohesive collections that are both modern and timeless. The second oldest of seven children, Joel's parents nurtured and encouraged his exploration of the arts. He received a bachelor of fine arts (BFA) in graphic design from Brigham Young University. Joel lives in Utah with his wife and four children.
www.joeldewberry.com

Q: How did you get started designing fabric?

A: Nearly a decade ago I struck up a friendship with an amazing woman, who worked for another textile manufacturer. Over the years, she went on to bigger and better things, and I continued to design in a number of different industries. In 2006 we reconnected by chance and she invited me to submit a collection of ideas for fabric designs. I knew little about designing fabric and even less about the quilting industry. And little did I know that Westminster Fibers was perhaps the best fit for my modern design aesthetic and vibrant use of color. Her invitation was the beginning of what has now come to fruition. I will be forever grateful for her friendship, trust, and confidence in me as a designer.

Q: How do you approach building your own personal brand?

A: As a student and practitioner of design there are numerous opportunities and niches of design available to explore. My preference from the beginning was always for branding and brand development. I was intrigued by the opportunity to thoughtfully tell a visual story about a company or product through its brand.

I began to ask myself the question, "If I had a brand, what would it be and what would it look and feel like?" This question stuck with me, and about four years ago I was given the opportunity to answer it by defining my own brand and developing a product line. I could not have asked for a more exciting opportunity. My years of experience, successes, and failures added to what my brand became. It was exciting to be interviewing myself, instead of a client, to determine what my brand meant, who it was for, and how it would grow in the future. And perhaps more rewarding than anything else was the fact that I was in complete control. Even down to the fabric designs themselves, Westminster Fibers extended me a generous amount of creative liberty, which allowed me to experiment and deliver unique designs addressing a rather new category in the market at the time.

3

4

1 Sunflower Lake quilt. © Joel Dewberry 2010

2 Chestnut Hill and Aviary fabrics. © Joel Dewberry 2010

3 Majestic Oak by Joel Dewberry for FreeSpirit Fabrics

4 Tiles by Joel Dewberry for FreeSpirit Fabrics

Q: Do you remember what it was like when you saw your first printed fabric collection?

A: The memory of unpacking my first completed and printed fabric collection is rekindled each time I receive that first shipment for a new fabric line. I am reminded of how fortunate I was to have had the opportunity to create something tangible and lasting. To see my designs translated onto beautiful cotton fabric was the ultimate reward. Equally rewarding was the realization that my designs were now a tool or medium for other designers and artists to embrace in the creation of their own craft.

Q: What are the differences in designing quilting and home décor fabrics?

A: Perhaps the biggest difference is the contrast in scale. Quilting prints are normally smaller scale, while home décor prints are historically larger in scale to accommodate larger applications. Personally, I believe the lines between the quilting and home décor fabrics are blurring ever so quickly, especially if you adopt the philosophy that quilting is simply an extension of one's home décor. I continue to observe a steady migration of larger scale prints into quilting fabric lines. I am a designer who likes to challenge that status quo and inject large, bold designs in my quilting collections. I believe this will ultimately help quilting to continue to evolve as an art form and ensure its relevance to a rising generation of crafters and sewers. I am excited to be invested in the quilting industry.

Q: How do you collaborate with the rest of your studio/team?

A: My studio or team is rather small. It consists primarily of "me." I do, however, engage my wonderful wife as a sounding board to make sure I haven't ventured to a place in my design exploration that is too far off from what people will like. Often I think how nice it would be to make the design process more collaborative, but I also recognize that I thrive in the autonomy of my current method. Doing it in this way ensures it is still a practice of personal expression and that each new collection is as rewarding as the last.

Q: How do you name your collections?

A: I enjoy the naming process. I actually treat the name like another design element that contributes to the overall success of the particular collection. I believe, and I hope, that my design collections create an atmosphere and have the ability to transform someone's environment into something new and exciting. Most often, I have found that I name a design collection based upon the origin of the inspiration for it. It may be one signature design that was the building block for all others or it might be a beautiful place I visited that inspired me to sketch and create. This formula seems to ensure that my designs retain a sincerity and that I don't just haphazardly design cool shapes. I like there to be a story that attaches itself to the creation of a particular line.

DEVELOPING COLLECTIONS FOR LICENSORS AND OTHER PRODUCTS

Written in collaboration with J'net Smith, All Art Licensing

In addition to approaching manufacturers to license your designs for textiles, your designs may also be a great fit to use in other categories. If you look around your home or at the products on the shelves on your next shopping trip, you'll notice patterns are everywhere. Manufacturers from a wide variety of industries license art for use on their products.

Product categories
- Accessories
- Apparel
- Baby and children's domestics
- Food and beverage
- Gifts
- Health and beauty
- Home furnishings
- Housewares and home décor
- Publishing
- Sporting goods
- Stationery and paper goods
- Toys and games

Repeats vs. central images

When designing for textiles, patterns are created in repeat so they can be seamlessly reproduced across the width of the fabric. When designing for other categories, repeats may not always be the most effective way to feature artwork. In order to be the most saleable, artwork may be presented as a central image with coordinating patterns or borders.

When approaching manufacturers with products in categories outside of textiles, it is important you take the time to modify how you present your art so it's the most applicable for their use. Some guidelines to consider are listed below:

Central images
- Central images should be easily recognizable
- They should be unique and represent your style
- They must reproduce well on a diverse set of product types or materials
- Consider developing seasonal art that ties to popular merchandising calendars (e.g., holidays or events like graduation)

1 Present your designs as concepts that demonstrate how your patterns would appear on manufactured goods

1

Presenting concepts as applications

In Chapter 3 you'll find a tutorial on Texture Pattern Mapping. This process allows you to take your patterns or images and digitally "map" them onto a line art illustration. You'll find this process invaluable if you decide to approach manufacturers beyond those in the home sewing and quilting space. It gives you a way to demonstrate what your patterns would look like as upholstery on a chair, as a central image on a paper plate, or as a border on a photo frame.

The key to presenting your work to manufacturers is to make it easy for them to envision how they would use your designs. Presenting concepts as applications gives you a way to show off your art in a highly relevant way.

- **Central images:** One to four icons or images
- **Coordinating artwork:** Two to four patterns or borders
- **Color palettes:** Two to three palettes based on two to six colors. (It's important to keep in mind most products will be screenprinted, so you may need to limit your colors based on that printing approach.)
- **Categories:** Two with several items within each category. For example, for the Stationery category consider a greeting card, a calendar, and a journal. For the Home Décor category consider a platter, a picture frame, and a mug.

INTERVIEW
Paige Stanley Miller

After earning her BFA in textiles from the Rhode Island School of Design, Paige Stanley Miller and her husband created their own studio in 2001. After her first Surtex show, Paige signed a bedding license. Soon after, she began developing her prints for china, giftware, wallpaper, and other home products. Paige continues to license her designs across a broad range of categories, including sewing textiles.
www.paigestanleymiller.com

Q: How did you get started designing in the home décor market?

A: In Manhattan I've had the opportunity to work with great manufacturers who have helped me to further build my skill set. At The Echo Design Group I was initially a board artist, where I did layouts and paintings to create scarves mainly for museums and corporations in their custom area. At that time Computer Aided Design (CAD) was relatively new. I was able to train on how to use the system to color accessories and tabletop and wall-covering products. Next I worked for Westpoint Stevens, where I was part of a team that digitally interfaced our New York studios with their mills down south. It was a great chance to learn the different ways printed fabrics, wallpaper, and wovens are manufactured.

People kept encouraging me to have my own studio, so roughly 10 years ago I finally put out my own shingle. At my first Surtex show I signed a bedding license with Almeida. Shortly after, I signed a giftware license with Two's Company. I have licensed my prints to Design Design and M. Middleton for greeting cards and imprintable stationery and to Windham Fabrics for home sewing textiles.

Q: What do you see as some of the differences in designing for sewing fabrics vs. bedding or stationery?

A: When you are designing for the decorative and bed/bath categories, each print or woven needs to be an element that creates a specific atmosphere. With gifts, home sewing, and stationery you can be more thematic. In fact the more unique your theme is, the better—as long as it is saleable—because it will distinguish you from other designers. A special way that you paint, draw, collage, or however you make your art will be important as well. In the stationery and wallpaper markets, designs that lend themselves to borders and embossing become important.

It used to be that humorous designs were limited to the juvenile category in home décor. That is really changing, as a lot of consumers are showing that they enjoy a "playful mix!"

1 Juliet. © Paige Stanley Miller for Windham Fabrics

2 Bon Vivant. © Paige Stanley Miller for Windham Fabrics

3 The Big Blowout. © Paige Stanley Miller for Windham Fabrics

4 Golightly Paisley. © Paige Stanley Miller for Windham Fabrics

5 Camille Paisley. © Paige Stanley Miller for Windham Fabrics

Q: What do you do when you're suffering from lack of design inspiration?

A: When I'm blocked in the studio, it may be time to see some friends, go to a movie, go to a museum, or take a trip. Trend forecasts are really important, but I believe that your personal experience will give your art its most unique character.

Q: What is your favorite category to design for? Are there other categories you'd like to design for?

A: Currently my favorite category to design for is home sewing fabrics. Companies like Windham Fabrics have a real appreciation of unique novelty art and understand the value of building brands with designers. I'm very interested in designing for ceramic, craft, loungewear, and rug categories as well.

Q: What advice would you share with someone who wants to get started as a textile designer?

A: I had a great illustration teacher at Parsons for greeting card design. He said "Show your work. You may have to meet with a lot of people but it is so worth finding your audience."

INTERVIEW
Heather Moore, Skinny laMinx

Heather Moore is an illustrator and designer living in Cape Town, South Africa, where she produces her own line of textiles, home goods, and children's apparel featuring her designs for her label, Skinny laMinx. She also authors the popular and inspirational blog under the same name, where she shares her work, her approach to design, and tidbits from her life and her business. Her wares are distributed through her online shop, across the internet, and through an ever expanding list of boutiques worldwide. Additionally, Heather edits the blog for Elle Decoration South Africa (elledecoration.co.za).
www.skinnylaminx.com

Q: What is your design background?

A: After university, where I studied English and drama, I fell by chance into book illustration. I did this for about 10 years, along with some materials development in the education sector, some postgraduate study, and a stint as a comics scriptwriter. I have no formal training in design and am pretty much self-taught, making it up as I go along and learning things through trial, error, and observation.

Q: How would you describe your design style?

A: Many of my designs start out as paper cuts, and this seems to result in a simple and clear style, with flat colors and friendly shapes. I find myself drawn to graphic design and illustration from the 1950s and 1960s, and like to think that my design reflects a bit of this era's feel.

Q: How did you get started designing textiles?

A: About five years ago my husband gave me a silk screen and squeegee for my birthday, and I started cutting screenprint stencils from paper. I started out making one-off screenprinted and stitched cushions, then moved on to tea towels, using professionally exposed screens. My first tea towels were sold at the beginning of 2007, while I was still illustrating and freelancing as a comics scriptwriter, and soon after that I started my Etsy shop, which grew from strength to strength. As the demand grew, so did requests for my prints in a format larger than a tea towel size, so at the beginning of 2009 I started producing yardage.

1

2

Q: You have done a tremendous job with your grassroots marketing. Can you talk a bit about how you have gotten your work out there and noticed?

A: When I started out, I think timing really was on my side. At the same time that my enthusiasm for textiles was growing, I discovered the Internet and blogging, and enjoyed sharing my discoveries with what was a relatively small design blogging community at the time. I was fortunate to get some great publicity early on, courtesy of blogs like Design*Sponge, Decor8, and Poppytalk, and this helped to grow my blog readership, as well as awareness of my little Skinny laMinx brand.

I think the attention my work has received in the media—both print and online—is an example of the new way of marketing that the Internet has brought about. I've found the design blogging network to be a generous and friendly one and, of course, it's constantly hungry for newness, so is keen to put out word of a new design or product. Stores and print media are using the Internet to source things, and my brand has reaped the benefit of this.

Q: What role does blogging play in how you market your work?

A: Blogging about my work is not a calculated marketing technique at all. I blog because I enjoy documenting my process and my enthusiasms, using it as a journal of my own development. My blog is not just a list of new things I've designed and have for sale, but it's about things that catch my eye, my failures, my attempts to bring order to studio chaos, so there's a narrative behind the designs that is enjoyable to keep track of.

Blogging has also helped me develop skills useful to my business. In particular, documenting things for my blog has improved my photographic composition and awareness of lighting, and I've learned a lot about Photoshop. As I take all my own product shots, this has been great, and I'm really seeing an improvement in my styling and picture quality.

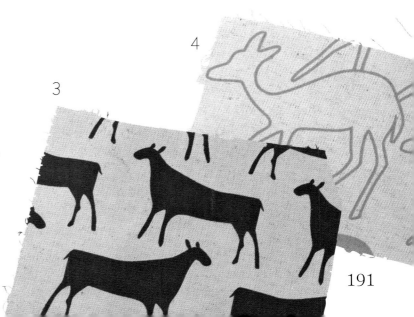

4

3

1

Q: What role does collaboration with other designers play for you?

A: I've been fortunate to collaborate with a number of amazing designers. I was very lucky to collaborate on a set of letterpress cards for Lynn Russell of Satsuma Press. I've designed bags, tea towels, aprons, and letterpress cards for Heath Ceramics, and I am collaborating with Michelle Bencsko on a collection of quilting fabrics for her organic textiles company, Cloud9.

Cape Town has a small but vibrant group of small-scale textiles businesses, and while it's not a huge city, I realized last year that I'd hardly met any of them. For this reason, I decided to start the Threadcount Collective, which is a loosely woven grouping of fabric designers and producers, and we get together once a month or so to share our experiences, contacts, opportunities, and resources. It's a wonderfully generous and supportive group, and I've learned a great deal from every member.

Q: What approaches have you followed to get your products into recognized showrooms and outlets? What advice can you offer to someone looking to expand their distribution channels?

A: All the opportunities I've had to get my things into stores and outlets across the world have not come as a result of effort on my part, but from people approaching me. And, as with my career in illustration and design, I've just learned things as I've gone along—mostly on an urgent, need-to-know basis.

I think the fact that my things have been so visible online has been the key factor in having so many stores interested in my work, and also the fact that I've been consistent in my output of new things. When the first store approached me about wholesaling to them, I had no idea how to go about it, and in my terror, I ignored the request. I had never heard the term "line sheet" before, had no idea how to cost things, knew nothing about exporting, and so I had to learn fast. I bought Meg Mateo Ilasco's book *Craft Inc.*, which was hugely instructive, both in practical terms—so that's what a line sheet is!—and in giving me a sense that what I was doing could become a lot more than a pleasant pastime.

3

2

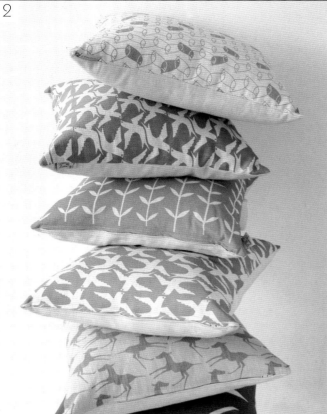

1 Cloud Birds smock dress
2 Cushions in various fabrics
3 Leaves
4 Eeps
5 Leaves cushions

Q: What's next for Skinny laMinx?

A: My business has really grown ridiculously quickly over the past little while. It's become a bit of an out-of-control hobby, and I have been feeling that I'm being dragged along by it, with events and opportunities leading the way without my having much say in what happens next. It's quite exhausting being reactive like this all the time, so I've decided to lead the way a bit more, getting advice and assistance from people with skill and practice in all the stuff I've been doing by the seat of my pants.

Q: Do you have any "oops" stories you can share? The kind of thing you might do differently if you had a chance to do it over?

A: I'm afraid that the mistakes I've made have been large and expensive and wasteful. But seeing as I didn't ever study any of this stuff—neither design nor business—I like to think of the money I waste on my mistakes as "school fees," and find that's a good way of getting over the pain and occasional embarrassment.

5

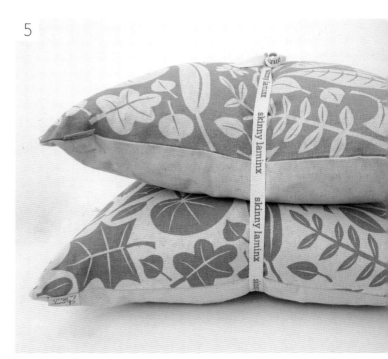

4

193

DEVELOPING A MARKETING PLAN

Depending on what direction you plan to take with your designs, there are a variety of approaches you may decide to adopt to start to build visibility for yourself. The approach I follow in my own marketing is based on my experience working in corporate advertising and marketing for nearly twenty years. What is detailed here is a simplified approach, and I encourage you to expand on it if you have experience in marketing. But regardless of whether you are an expert marketer or a newbie, my hope is to give you a basic structure against which to plan your own marketing efforts.

Why write a marketing plan?

There are lots of different avenues you may decide to take with your marketing. But with limited hours in the day, and knowing that money doesn't grow on trees, you'll want to build a solid plan to ensure you're getting the most out of your time and investment. A strong marketing plan doesn't need to be an expensive undertaking, though. Taking the time to write out a plan to define your objectives and the tactics you plan to use to meet those objectives will help keep you focused and allow you to get the most out of the money you spend to build your personal brand.

What is a marketing plan anyway?

Very simply, a marketing plan is a document that details your marketing objectives and the list of tactics you plan to use to meet those objectives. Plans are generally developed with a six- or twelve-month view, meaning you'll create a new plan at the end of each period that builds on your previous successes and what you learned from your mistakes. You should revisit your plan periodically and make modifications as you see how your plan plays out in real life.

To get started on developing your plan, ask yourself the following questions:
- What is my vision statement?
- What are my objectives?
- What is my brand personality?
- What am I selling?
- Who am I selling it to?

What is my vision statement?

This is the long-term vision for what you want your business and your brand to become. It should inspire you and define at a very high level what you want to do and how you want to get there. If you're having trouble coming up with your statement, try thinking about it in terms of answering the question: "What does the Hollywood movie version of my business and brand look like?" This is your chance to dream big and create that

ideal vision for what you want your business to become. Try narrowing it to one or two sentences so you can easily remember your vision statement, since you should frequently refer back to it in order to ensure your efforts are always moving you toward that vision.

What are my objectives?

Objectives are statements against which you can measure your success. Your vision statement is aspirational and your objectives are how you will quantify how you're doing in getting closer to that vision. They are usually time-based (e.g., within six months; on a quarterly basis) and can be measured (e.g., in revenue, new customers, new design collections, new licensing deals signed).

What is my brand personality?

One of the challenges you may face in defining your brand personality is selecting the specific words to describe your style. As you're building your brand, it's important for you to be consistent in the language you use to describe who you are and what your brand personality is. The more consistent you can be, the easier and more natural it will become for you to speak and write about your brand, which helps to support all of the work you'll be doing around marketing and advertising.

This is a great time to reach out to your network of friends and family and get some help. This is a fun exercise and I bet you'll be surprised at what you find.

- Start by pulling together some samples of your designs that are representative of your style. You can either post them online (on a site like Flickr) or you can combine them in a simple PDF you can attach to your email.
- Select thirty or forty people. Send them an email and ask them to review your designs and share their thoughts with you on words or phrases that encapsulate the spirit of your brand. Some examples of phrases from the world of textiles and décor include: Amy Butler—"Midwest Modern"; Kelly Wearstler—"Hollywood Regency"; Jonathan Adler—"Happy Chic".
- Then you might want to throw out some of your own ideas to get them started. Here are a few from the email I sent to my network when I was developing my own brand personality: Playful Classics; Modern Reimagined; Rebellious Chintz; Classical Reinterpreted; Simplicity with a Witty Twist.

At the end of my exploration, I landed on Playful Stylish. Any time I speak about my brand or write about who I am, that idea is woven into what I say.

Product or service	Target market
Art and designs	Textile and home décor manufacturers
Fabric	Sewists, DIY crafters, quilt fabric retailers
Cushions made from your fabric	Home décor enthusiasts and retailers

What am I selling?

Depending on what you're trying to achieve with your business and the financial objectives you've defined for yourself, you may be selling a variety of different products or services associated with your designs.

For instance:

- selling or licensing your art to textile manufacturers
- selling or licensing your art to manufacturers in other categories
- offering products for sale:
 - > printing your own fabric
 - > creating goods or products from your fabric (e.g., pillows)
 - > creating products out of other materials that feature your designs (e.g., paper stationery)

Who am I selling it to?

Based on what you're selling, who you're selling to may vary widely. Clearly understanding the differences between your target markets will be a key aspect of how you structure your marketing plan. It can help you understand where to spend your money and your time, and what promotional methods or tactics will be the most effective to get them to notice you.

If one of your objectives is centered around getting your art and designs licensed by manufacturers, some of your marketing tactics may include trade shows and sending direct mail or email so manufacturers become familiar with your work. If another one of your objectives is centered around selling pillows made from your fabric, your tactics may include getting your pillows into boutiques and working on your PR so you can be mentioned in home décor blogs or magazines.

Once you have an understanding of your target markets, spend some time thinking about who they are, what they read, where they shop, and what needs they have that you can help to meet. Refer back to who your target markets are as you make decisions about where to focus your efforts and your cash.

General	*Scheduled*	*Ongoing*
Initial investments or one-time development	Are executed at specific times throughout the year	Require continual care and feeding
• Logo • Business cards • Paper system • Biography	• Email marketing and newsletters • Direct mail • Trade shows or events • Advertising • Brochures or catalogs	• Website • Public relations • Blogging • Social networking • Developing a sales leads list

Marketing tactics

Next you're going to start to build a road map for yourself by identifying which marketing tactics you'll use to reach your objectives. I find it helpful to lay my tactics out against a calendar. This allows me to define weekly or monthly goals for myself and it helps to make sure I don't sign up to do more than I can manage successfully or afford to fund. Although this list is not all inclusive, it will give you a starting spot for mapping out your tactics.

Online marketplaces

Part of the revival of independently produced goods has converged with technology to provide the perfect platform for the rise of online marketplaces. These sites are filled with handmade goods and are frequented by buyers looking

www.dawanda.com

www.envelop.eu

www.etsy.com

www.folksy.com

www.spoonflower.com

www.zazzle.com

specifically for unique items created by independent artisans. These marketplaces are like giant 24/7 craft fairs and are an inexpensive way to build an online store where you can offer your goods for sale. In addition to being easy to set up with very low costs, these online stores have the added benefit of coming with built-in traffic. So although you most definitely need to work on your marketing to drive traffic to your store, these sites have millions of members who shop on a regular basis.

Social networking sites

Although you may already use social networking for staying in touch with your friends, colleagues, and family, you should explore the possibilities that social networking offers you around building your personal brand. Whether you blog, tweet, or post (or do them all), they all provide you with an opportunity to reinforce your brand personality. You can share a bit more about who you are (the person behind the business), how you spend your days, and exciting happenings with your business. People will quickly tire of your news, though, if it's all centered around your latest sale and promotion. So make sure you keep your content fresh, interesting, and relevant to your readers.

TRADE SHOWS

Depending on your objectives, your marketing plan may include exhibiting at one or more industry trade shows. Trade shows are a wonderful venue to allow you to develop relationships, broaden your visibility in the marketplace, and learn more about your competition. But exhibiting at a show isn't a trivial activity, both in terms of time and investment. As you consider your budget, make sure you look at all aspects of exhibiting at a show.

Develop your budget

- **Booth fee:** This fee is charged by the show management. Check to see what's included; for some shows, the fee may be "all-in," which would include your booth space, the walls, table, chairs, electricity, carpet, and lights. For others, the fee may only include the space.
- **Preshow marketing:** Build a list of prospective customers. Call, email, or send them direct mail to set up appointments and bring them to your booth. You'll certainly make unexpected contacts at the show with people who simply walk in to your booth, but you'll have a more productive show if you set up as many appointments as possible.
- **Print advertising:** Each show will have several printed publications or guides where you may consider buying advertising space. These guides are often used by show attendees to preplan which booths they plan to visit and they are often kept after the show as reference materials.

- **Signage:** Your booth needs to stand out among the sea of other booths, so make sure your art is both impactful and representative of your brand. You may be better served to display fewer of your designs on the walls (eight to fifteen) rather than try to display too many. Remember that people are walking the aisles pretty quickly so your booth needs to be designed to stop traffic and draw them into your space.
- **Collateral:** Make sure you have plenty of business cards to hand out! You should also consider a brochure or postcard that you can hand out as a takeaway.
- **Portfolio and mock-ups:** You'll want to bring samples of your work and present them in a way that is relevant to the people visiting your booth. If you're exhibiting at Quilt Market, you'll need lots of samples of your fabric and goods made from your fabric. If you're exhibiting at Surtex and your art has been licensed for products, bring samples to demonstrate how your designs translate into actual goods. If your art hasn't been licensed yet, consider creating a few mock-ups to show what a product could look like with your patterns. Your portfolio should include work that is representative of your style and should be easy to view.
- **Giveaway:** You may consider an inexpensive giveaway for visitors to your booth. Your goal is to provide something they will keep and take home. Just make sure your name and contact information are included on every item.

- Surtex, New York, May
 www.surtex.com
- Print Source New York, three times per year: spring, summer, fall.
 www.printsourcenewyork.com
- Licensing International Expo, Las Vegas, June
 www.licensingexpo.com

- International Quilt Market, Houston, spring (location varies each year)
 www.quilts.com
- Brand Licensing Europe, London, fall
 www.brandlicensing.eu

- **Press materials:** Before the show, contact key industry press and bloggers and let them know you're exhibiting. This is your opportunity to get press mentions as part of their preshow coverage, so make sure you provide them with something newsworthy to talk about. Make sure you have press kits available at the show.
- **Travel:** Make sure you set aside budget for airfare, hotel, and food. You may also need to plan to cover travel costs for a second person to travel with you as help in the booth.
- **Postshow marketing:** Keep detailed notes about every conversation you have with prospects and customers at the show. Once you head home, it will be up to you to follow up with those contacts and send them what they asked for. Your costs here will likely be primarily in time rather than in dollars, but if you don't follow up on your leads, most of your show investment will be wasted.

Walking the show

If exhibiting isn't the right thing for you, or if you just want to see what a show is like, make plans to walk a show or two. Attending a show and walking the floor to visit all the booths is a wonderful way to get your bearings and see how other designers are presenting their work. Often there are seminars and other educational opportunities included as part of your show registration fees.

Surface and textile design shows

Depending on what direction you are hoping to go in with your art and textile designs, there are several shows you may consider. Each show has its own personality and purpose. Quilt Market is focused mainly on wholesale to the quilting and home sewing textiles retailers, while Surtex, Printsource, or the Licensing Expo are more targeted toward manufacturers looking for art to use on their products. Whether you decide to attend as an exhibitor or simply as an attendee, there are a wide variety of trade shows and industry events specific to the surface, pattern and textile design industry. The list above is not comprehensive but highlights several of the larger shows.

General tips and advice

I exhibited for the first time at Surtex in 2010 and received some wonderful advice from industry veterans I met.

- Project confidence and be approachable; no one wants to talk to someone who looks terrified, bored, aloof, or angry.
- Develop a plan for managing your leads. It doesn't have to be complex, but make sure you have a clear plan for how you'll keep track of who you met, what they were interested in, and what you promised to do as a follow-up.
- Business may be slow the first year, but make the commitment to keep exhibiting. It can take time to build your brand and to make a name for yourself.
- Following up after the show is as important as the show itself. If you wait for them to call you, you could be waiting a very long time . . .

RESOURCES

Supplies

Atlantis Art Materials & Art Supplies
www.atlantisart.co.uk

Dharma Trading
www.dharmatrading.com

Dick Blick Art Materials
www.dickblick.com

Eckersley's Art & Craft
www.eckersleys.com.au

Hobby Lobby
www.hobbylobby.com

Itajimi Supplies
www.r0ssie.etsy.com

Jerry's Artarama
www.jerrysartarama.com

Jo-Ann Fabrics and Crafts
www.joann.com

Michael's Arts & Crafts Stores
www.michaels.com

Pro Chemical and Dye
www.prochemicalanddye.com

Silk Screening Supplies
www.silkscreeningsupplies.com

Books

Adobe Photoshop for Textile Design
Frederick L. Chipkin (Origin Inc.)

Color Your Cloth
Malka Dubrawsky (Lark Books)

Craft, Inc.
Meg Mateo Ilasco (Chronicle Books)

Creative, Inc.
Joy Deangdeelert Cho and Meg Mateo Ilasco
(Chronicle Books)

Designing & Printing Textiles
June Fish (The Crowood Press)

Digital Textile Design
Melanie Bowles and Ceri Isaac (Laurence King Publishing)

Graphic Artist Guild Handbook: Pricing & Ethical Guidelines
(Graphic Artists Guild)

Licensing Art & Design
Caryn R. Leland (Allworth Press)

Principles of Pattern Design
Richard M. Proctor (Dover Publications)

Printing by Hand
Lena Corwin (Stewart, Tabori & Chang)

Print Your Own Fabric
Linda Turner Griepentrog and Missy Shepler
(Krause Publications)

Textiles: A Handbook for Designers
Marypaul Yates (W. M. Norton & Company)

The Small Design Company's Guide to Wholesale Fabrics and Trims
(The Fashiondex)

The Surface Designer's Handbook
Holly Brackmann (Interweave Press)

Magazines

American Craft
www.americancraftmag.org

Surface Design Journal
www.surfacedesign.org

Selvedge
www.selvedge.org

Textile Forum
www.textileforum.com

Software and equipment

Bitmap editing programs:

Adobe Photoshop
www.adobe.com

Microsoft Paint
www.microsoft.com

Corel Photo-Paint
www.corel.com

Art Rage
www.artrage.com

The GIMP (free download)
www.gimp.org

Get Paint (free download)
www.getpaint.net

Vector-based drawing programs:

Adobe Illustrator
www.adobe.com

CorelDRAW
www.corel.com

Serif DrawPlus
www.freeserifsoftware.com

Inkscape (free download)
www.inkscape.org

Wintopo (free download)
www.wintopo.com

Digital stylus manufacturers:

Genius
www.geniusnet.com

Trust
www.trust.com

Wacom
www.wacom.com

Useful websites

Computer Arts
www.computerarts.co.uk

Entrepreneur
www.entrepreneur.com

Lynda: Online Software Training & Online Tutorials
www.lynda.com

Print & Pattern
http://printpattern.blogspot.com

Printspecs
http://print-specs.blogspot.com

True Up
www.trueup.net

Trade associations

American Association of Textile Chemists & Colorists
www.aatcc.org

European Textile Network
www.etn-net.org

International Textile and Apparel Association
www.itaaonline.org

Surface Design Association
www.surfacedesign.org

Textile Society of America
www.textilesociety.org

GLOSSARY

Block printing

A type of printing whereby motifs are printed with blocks (often made from wood or rubber).

Block repeat

Images form a grid following horizontal and vertical lines; also called a straight repeat.

Brick repeat

Images are moved halfway horizontally to the next image.

Color models

Different methods of associating numeric values with colors.

Color palette

A group of colors used in a design.

Color wheel

A simple tool that shows the relationship between colors.

Half-drop repeat

Images are dropped halfway vertically to the next image.

Mirroring

Flipping images in a design along the vertical or horizontal axis so that the images face different directions.

Mood board

A way to organize ideas and define an approach for a design; often manifested as a physical collection of items pinned to a board.

Motif

An element or shape that makes up part of a design.

Multidirectional pattern

The pattern of the design is viewed correctly upside down or right side up.

Perspective

When applying a pattern to a shape, perspective is a technique used to make the shape appear three-dimensional.

Random repeat

Images are randomly placed with no discernable pattern within the repeat; also called a tossed pattern.

Repeat

Laying out or setting up a design in a manner that it will come together seamlessly in a continuous pattern.

Resist dyeing

A method of dyeing textiles with patterns whereby different methods are used to prevent the dye from reaching the fabric, creating a pattern.

Screenprinting

A method of printing fabric whereby the pattern is applied as an ink-blocking stencil onto a fine-meshed screen; using a squeegee, the ink is then forced through the screen onto the fabric.

Shibori

A variety of fabric resist that creates patterning through binding, stitching, compressing, folding, and twisting.

Single-direction pattern

All of the elements of the pattern are facing in the same direction.

Stencil printing

A method of applying a pattern by brushing, rolling, or squeegeeing ink through the open areas of a stencil (often made from plastic or cardboard).

Straight repeat

Images form a grid following horizontal and vertical lines.

Tessellation

A pattern created by continuously repeating a shape to completely cover the plane in interlocking patterns, leaving no blank areas or overlaps between the objects.

Toile de jouy

A type of conversational motif that often uses pictures of scenes from daily life.

Vat dyeing

The process of applying color to fabric by immersing in a bucket or vat filled with liquid dye.

1 Yellow Scallops by Liz Scott

INDEX

CONTRIBUTORS AND INTERVIEWEES

Jennifer Berney, Formosa Design
www.formosadesign.com.au

Jessica Blazek
www.artbyjess.etsy.com

Jesse Breytenbach, Jezze Prints
www.jessebreytenbach.co.za

Natalie Callwood
www.dyluzo.etsy.com

Lara Cameron and Tegan Rose,
Ink & Spindle
www.inkandspindle.com

Kerry Cassill
www.kerrycassill.com

Claudia Corimer
www.howbeadyful.etsy.com

Sahara Dalley
www.papatotoro.com

Danielle Stewart Design
www.daniellestewartdesign.com

Joel Dewberry
www.joeldewberry.com

Malka Dubrawksy, A Stitch in Dye
www.stitchindye.etsy.com

FreeSpirit Fabrics
www.freespiritfabric.com

Karin Grow
www.karingrow.etsy.com
www.karingrow.blogspot.com

Lotta Helleberg
www.inleafdesign.com

Hippopotamus Gifts
www.hippopotamusgifts.etsy.com

Sara Hopp Harper, 5 o'clock crows
www.fiveoclockcrows.blogspot.com

InkBloom
www.ink-bloom.com

Kailo Chic
www.kailochic.com

Samarra Khaja
www.samarrakhaja.com

Cherie Killilea
studiocherie.etsy.com

Josephine Kimberling
www.josephinekimberling.com

Hitomi Kimura, Kalla Designs
www.kalladesign.com

Isabelle Kunz, Trois Miettes
www.troismiettes.com

Shannon Lamden, Aunty Cookie
www.auntycookie.com

Paul Loebach
www.paulloebach.com

Marimekko
www.marimekko.fi

Melisa McKeagney
www.littlegirlpearl.com

Michael Miller Fabrics
www.michaelmillerfabrics.com

Paige Stanley Miller
www.paigestanleymiller.com

Nancy Mims, Mod Green Pod
www.modgreenpod.com

Heather Moore, Skinny laMinx
www.skinnylaminx.com

mummysam
www.mummysam.com

Deborah O'Hare
www.quiltroutes.co.uk

P&B Textiles
www.pbtex.com

Pierre Frey
www.pierrefrey.com

Robert Kaufman Fabrics
www.robertkaufman.com

Heather Ross
http://heatherross.squarespace.com

Julia Rothman
www.juliarothman.com

Liz Scott
www.lizscott.com

Jun Shirasu
www.shirasstudio.blogspot.com

Simbiosis
www.simbiosisbyjulia.etsy.com

ACKNOWLEDGEMENTS

J'net Smith
www.allartlicensing.com

Smock
www.smockpaper.com

Spoonflower
www.spoonflower.com

Sultan Chic
www.sultanchic.com

Lucie Summers
www.summersville.etsy.com

Umbrella Prints
www.umbrellaprints.com.au
www.umbrellaprints.etsy.com

Westminster Fabrics
www.westminsterfabrics.com

Windham Fibers
www.windhamfabrics.com

Yardwork
www.yardwork.etsy.com

Holli Zolliger
www.spoonflower.com

To my family and friends: Your unwavering support astounds me, and I am deeply grateful to have you in my life. Thank you for your words of encouragement, for patiently listening to me drone on and on about "the book," and for sharing your insights. With you by my side, I never feel as if my goals are beyond my grasp. (And of course, many thanks for pouring me that occasional glass of wine or gin and tonic . . .) An extra-special thank you to my mom, dad, sister Wendy, Jan, Danielle, Curlin, Alison, Kevin, Margaret, Joe, Charlotte, and Natalie. You never let me lose faith in myself and always keep me giggling.

To Isheeta, Jane, Emily, and the entire team at RotoVision and Chronicle Books: Your patience with a book-writing neophyte was tremendous. With your expertise this book is so much more rich and beautiful than I ever imagined it could be.

To my amazing photography and styling duo: Ryann and Robin. My heartfelt gratitude for helping me take my creative vision and translating it into such gorgeous imagery to support the text. Thank you for giving up so many of your weekends to help me make this happen and for sharing your wonderful ideas.

To the team at Spoonflower, especially Stephen, Kim, and Danielle: I can't thank you enough for all of your encouragement, support, and for continually teaching me more about digital printing and color management.

To the designers and experts who contributed tutorials, interviews, and time to review my content and provide feedback: Your voice and expertise have added depth to the text I could never have achieved on my own.

And finally to all the wonderful designers from Spoonflower, Etsy, and Flickr who allowed me to include their designs, products, or photography. Your tremendous talents never cease to amaze; thank you for your enthusiasm for this project.

ABOUT THE AUTHOR

Laurie Wisbrun is a surface and textile designer and author of the blog Scarlet Fig. She has a twenty-year background in marketing and is self-trained as a designer. She began designing fabric when she jumped off the corporate hamster wheel and was searching for a career where she could create designs that would surprise and delight retailers and consumers. Her aesthetic is about finding beauty in ordinary objects and patterns and playfully transforming them into stylish and modern designs with unexpected content and color combinations. Laurie has designed a number of international fabric collections, has licensed her designs to a number of home décor and stationery manufacturers, and sells limited-run fabric via her online Etsy store. She lives in Austin, Texas, USA.

www.lauriewisbrun.com

Credits

Original photography by Ryann Ford
www.ryannford.com
Photo styling by Robin Finlay

Image 1 on page 18, image 2 on page 23, and all images on pages 28–29 were supplied by Marimekko and are copyright © Marimekko.

PHOTO BY LISA WOODS | www.nowandthenphotography.com